Nabeshima

FAMOUS CERAMICS OF JAPAN 1

Nabeshima

Motosuke Imaizumi

KODANSHA INTERNATIONAL LTD.
Tokyo, New York, San Francisco

distributed in the United States by Kodansha International/USA, Ltd.,
through Harper & Row, Publishers, Inc., 10 East 53rd Street,
New York, New York 10022

published by Kodansha International Ltd., 12–21 Otowa 2-chome,
Bunkyo-ku, Tokyo 112 and Kodansha International/USA, Ltd., 10 East
53rd Street, New York, New York 10022 and 44 Montgomery Street,
San Francisco, California 94104

LCC 80–84463
ISBN 0–87011–415–8
JBC 1072–789439–2361

Nabeshima Ware

Nabeshima ware was instigated by Naoshige, lord of the Nabeshima clan of Saga Province, who came into direct contact with the advanced Yi dynasty wares of Korea while participating in the warlord Toyotomi Hideyoshi's invasions of that country in the 1590s. Upon his return to Japan, Naoshige brought back with him a number of Korean potters in order to develop a domestic ceramic industry in his own fief. One of these Korean craftsmen, Lee Chanpyong (known as Ri Sanpei or Kanagae Sanpei in Japan) eventually discovered abundant deposits of excellent porcelain clay in the Arita area of northern Kyushu. The Japanese had hitherto relied upon imports of fine porcelains from China; this was the first find of native porcelain materials in Japan, and the first production of specifically Japanese porcelain is reputed to have begun in the 2nd year of Genna (1616).

Arita porcelain ware was thus first produced largely by Korean potters. Because the wares of the porcelain production area known as Arita-Sarayama were shipped to the provinces from the port of Imari, they eventually came to be known throughout the country by the name of this port and are consequently referred to as *Imari-yaki* (Imari ware). This name later spread to the West, thanks to Dutch traders stationed at Dejima in neighboring Nagasaki, who exported large quantities of these porcelains to Europe.

When the Nabeshima clan became aware that porcelain clay was not to be found in other parts of Japan and that Arita porcelain would thus make an extremely profitable export item, measures were taken to protect and ensure the prosperity of the industry. A limit was placed on the number of craftsmen employed, and those artisans specializing in overglaze enamels were kept separate from those engaged in the production of other wares.

These measures have ensured that Arita overglaze-enameled porcelains have enjoyed an uninterrupted 360 years of production and prosperity. For its part,

the Nabeshima clan established kilns under its direct control to produce gifts for the shogun and feudal lords of other clans, and to make pots for its own household use and to give to clan retainers as a form of reward for services rendered. The porcelain now known by the name of Nabeshima was produced by the clan's own kiln at its own expense at Ōkawachiyama near Imari. Today, Nabeshima pieces are regarded as masterpieces of ceramic art, displaying the highest technical excellence, and are treasured by collectors throughout the world.

Until the Meiji period (1868–1912), few in Japan, not to mention in other countries, knew where Nabeshima porcelain was produced, since it was not made to be sold on the general market. The Japanese public, therefore, did not see any value in these wares, and during the turbulent early years of the Meiji period, Nabeshima pieces were sold to foreign art dealers at incredibly cheap prices and shipped out of the country in quantity. The first to recognize the artistic value of Nabeshima porcelain was an Englishman who is thought to have worked as an official serving the Meiji government, a certain Captain Brinkley.

In the Taishō period (1912–25), a society of amateurs called the Saiko-kai ("Painted Pot Society") was established by Dr. Masatoshi Ōkōchi, the aristocrat and physicist who founded Japan's semi-governmental Institute of Physics and Chemistry. The members of this connoisseurs' society included business leaders of the day, and its aim was to collect and study old ceramics from all parts of the country. Dr. Ōkōchi published the results of this research in a book, which served to rouse wide interest in the study of Japan's ceramic heritage.

Thus, it was not until the second decade of this century that serious inquiry into the history of regional porcelains such as Ko-Imari (Old Imari), Nabeshima, Kakiemon, Ko-Kutani (Old Kutani), and Kyō-yaki (Kyoto pottery) was started. It was about

the same time that, thanks to the pioneer efforts of Dr. Ōkōchi, the interest in collecting old ceramics spread throughout the country.

When, where, and by whom were the first Nabeshima pieces produced? There is no way of knowing precise answers to these questions because no historical record has survived. However, the following chronology seems reasonable.

Period I—Kiln located at Iwaya-kawachi
32 years between 5th year of Kan'ei
(1628) and 3rd year of Manji (1660)
Clan kiln called *ondōguyama*

Period II—Kiln located at Nangawara-yama
13 years between 1st year of Kambun
(1661) and 2nd year of Empō (1674)
Clan kiln called *ondōguyama*

Period III—Kiln located at Ōkawachi-yama
196 years between 3rd year of Empō
(1675) and 4th year of Meiji (1817)
Clan kiln title changed from *ondōguyama*
to *goyōtōki-gama*

The name *ondōguyama* (roughly translated as the place producing "official utensils") is not mentioned in the official Nabeshima clan records and appears only in the family record of Soeda Kizaemon. It is thus impossible to determine precisely both how the clan kiln functioned in general and the particular role of successive generations of the Soeda family in the earliest production of this kiln. Only conjecture based on indirect evidence is possible.

It is recorded in writings about the early Iwaya-kawachi period that the very first generation potter, Soeda Kizaemon, studied celadon porcelain production under a certain Takahara Goroshichi and, after considerable difficulty, mastered the art of producing excellent celadon. (Takahara himself disappeared during the persecution of Christians at this time.) As a result of this achievement, Kizaemon was given the title of *teakiyari* and received the clan's regular patronage. His kiln became the *ondōguyama*. The *teakiyari* title was unique to the Nabeshima fief and was conferred on a commoner for great accomplishment in the service of the clan. It bestowed the status of samurai on the receiver. This speaks eloquently for the esteem given to celadon porcelain at the time. Although it is known that Kizaemon remained in Iwaya-kawachi for some thirty long

years studying celadon techniques, there is no evidence of what kind of celadon he made.

The existence of the second *ondōguyama* period is known only as a result of a passing comment made in the Soeda family record, where there is the passage: "*Ondōguyama* transferred to Nangawara-yama during the Kambun period." The Nabeshima official record, however, has nothing to say about this event. It is thus only the Soeda family record that gives evidence for the existence of a clan kiln and of the move that defines the first two periods of the *ondōguyama*. It does seem reasonable to assume that during these periods the Soeda family produced and worked to develop the quality of Nabeshima porcelain. Given the lack of historical material, we cannot determine why the *ondōguyama* was transferred from Iwaya-kawachi to Nangawara-yama during the Kambun period. This is one point that needs further investigation.

One reasonable supposition is that the move was made because the potters and products of Nangawara-yama were superior to those of Iwaya-kawachi. In documents dating from this time, names of potters such as Nakano Tokuemon (Tokubei) and Tokunaga Jōkō are mentioned as outstanding artisans at Nangawara-yama.

One theory has suggested that the moving of the kiln to Nangawara-yama was prompted by the need to learn the art of overglaze enamel painting from Sakaida Kakiemon I, believed to have been the first craftsman in Japan to master the art of overglaze enamel painting on porcelain. But this theory has been found to be inconsistent with what is known about the life of Kakiemon, and needs reassessment.

Another possible reason for the move may be found in the fact that during the Kambun period a type of cobalt and enamel decorated porcelain identical to that known as Ko-Kutani (Old Kutani) was being produced at Arita. Pots believed to date from this time are being reconstructed from excavated shards, and the work of classifying and sorting them is well under way, shedding more and more light on their historical origin and identity. Clarification of this matter is the immediate task today.

To return to the first theory mentioned above—the Kambun period saw large quantities of Kutani-style pieces produced for domestic consumption and, simultaneously, cobalt-decorated pieces in the Chinese style were produced in enormous quantities upon order from the Dutch East India Company, which

shipped them to Europe. Contemporaneous European documents reveal pertinent facts about these works imported from Japan. Indeed, it was these old European documents that unequivocally verified that the pieces famed for their milky-white background color were not shipped out of Japan until the Genroku period (1688–1704). These pieces are associated with the famed Kakiemon I, and this European evidence opens up the possibility that he lived around the Genroku period. However, it is not known if, in fact, he was a real historical figure, and the theory that the transfer of the *ondōguyama* to Nangawara-yama was made to obtain his expert instruction creates more problems than it answers and is doubtful at best.

What, then, was the reason for this transfer? One sensible conjecture is that the move was made in order to produce Kutani-style overglaze-enameled porcelain. To my knowledge, no one has ever shown any interest in pursuing this point further, and no headway has been made in casting light on it. After the war, I began to search for and collect a type of enameled porcelain that closely resembles Kutani ware and that seemed to me to have been made during the Nangawara-yama period. I eventually compiled a collection of shards and complete pieces of this ware and called this style *Matsugatani-de*.

The rarity of this *Matsugatani-de* category is evidenced by the fact that only ten complete pieces have been collected so far. "Matsugatani" normally refers to the location of the kiln belonging to the Ogi clan, which was an offshoot of the Nabeshima clan. This Ogi clan porcelain was produced after the Genroku period, but the *Matsugatani-de* pieces I introduced are pre-Genroku Nabeshima products.

The fact that so few examples of this *Matsugatani-de* type ware have been found leads to the conclusion that its production was very small; the Nangawara-yama Nabeshima kiln seems also to have produced the more brilliantly enameled type of orthodox Kutani ware today called *Nankin-de*. But so far I have not encountered any complete piece of *Nankin-de* that I can identify as being from the Nanagawara-yama kiln, and no definite conclusions can be drawn yet.

The third period is defined by yet another move of the *ondōguyama*, this time to Ōkawachi-yama, close to Imari. Here, again, we are left in the dark as to why this move was made, but I personally think that

the site transfer must have been prompted by the availability at Ōkawachi-yama of high-grade raw materials for porcelain and celadon glaze. Although it is not altogether impossible that the move may have been for the purpose of guarding the secrets of the Nabeshima techniques, the clan's strict controls should have sufficed to protect technical secrets wherever the kiln was located.

According to the Soeda family record, the family underwent a change in title in the Kyōhō period (1716–36). Though their official function did not change, their title changed from *ondōguyama-yaku* to *tōkigata-yaku*. The former connotes responsibility for the clan kiln, that is, the *ondōguyama* or "utensil manufactory," while the latter means responsibility for ceramic affairs (i.e., porcelain production). This implies that the official clan kiln system was completely established at this time, when the kiln became known as the *goyōtōki* kiln. The details of this change are not clear, but the *goyōtōki* appellation for the clan kiln (and the system accompanying this appellation) remained unchanged until the 4th year of Meiji (1871).

What is known as Nabeshima ware, then, is the porcelain produced by this clan kiln. Nabeshima porcelain was at its best during the Genroku through the Kyōhō periods. Pieces produced after the Bunka period (1804–18) are of inferior quality, and few of them even merit attention. This was a result of the fading prosperity of the Nabeshima clan, which found itself in increasing financial difficulties during the nineteenth century.

Organization and Operation of the Nabeshima Clan Porcelain Industry

During the first and second periods, when Nabeshima porcelain was produced in the clan kiln known as the *ondōguyama*, an official system of supervising porcelain production had not yet been established. It is thought that early production was on a relatively small scale and was experimental in nature.

There is no indication that the *ondōguyama* kiln started off by being elaborately organized. Rather, the origins of the kiln appear to stem from the simple fact that after much study and work Soeda Kizaemon succeeded in producing good celadon porcelain, and the Nabeshima clan, in recognition of this accomplishment, made the Soeda family solely responsible for porcelain production, this authority being hereditary

and to be passed down from one head of the family to the next.

It was not until the third period, when the kiln site was at Ōkawachi-yama and when the title "in charge of the *ondōguyama*" was changed to "in charge of ceramic affairs" in the Kyōhō period, that the clan set about making production more organized and arranged for quality pieces to be manufactured under standardized specifications. This happened under the regime of the clan's third daimyo, Tsunashige. This lord, who took the "art-name" Chitokusai, appears to have been rather extensively associated with the world of the arts, and it stands to reason that under his tutelage the kiln functioned as an important center of the clan's artistic activity for production of quality porcelain.

When the title "in charge of ceramic affairs" was instituted, a number of related positions were simultaneously introduced, it seems, including thirty-one posts for artisans with specific duties.

These artisans were selected from among the master potters of Arita-Sarayama. They were granted samurai status and were looked after by the Nabeshima lord, receiving clothing, food, and housing. Their response to the generosity of the Nabeshima lord was fervent: the porcelain of this time is unsurpassed in quality.

The thirty-one posts for artisans consist of eleven throwers; nine decorators in painting; four mold formers or perhaps modelers; and seven general workers. Note the emphasis placed on throwing.

Designs and patterns were painted according to instructions from the Nabeshima clan. Acting on these instructions, all those in charge—particularly members of the Soeda family—took great pains to achieve artistic perfection. Over a period of several generations, the Soedas refined firing techniques and also developed secret formulas for cobalt blue, celadon, and other glazes.

The Techniques of Enameled Nabeshima
The artisans of Arita-Sarayama involved in enameled overglaze porcelain work were divided into two groups—those who operated the enamel kilns (*kama-yaki*) and those who painted the overglaze enamel decoration (*aka-e ya*). This system was a clan-imposed institution, and there were eleven houses of enamel painters at Arita-Sarayama by the 12th year of Kambun (1672). My earlier interpretation of old documents was that there must have been

sixteen such houses from the beginning. Inspection of the Arita-Sarayama magistrate's records (*Sarayama daikan kiroku*) for the 2nd year of Hōreki (1752) reveals that ten houses of enamel painters besides that of Shōya Heibei (later the Imaizumi family) duly paid their taxes. Thus, there were eleven artisan's houses in the beginning, and these increased by five during the Meiwa period (1764–72). I wish to take this opportunity to correct my earlier incorrect interpretation.

The clan pottery at Ōkawachi-yama used to send enamel-decorated pieces all the way to the enamel artisan's area at Arita-Sarayama to be fired. This is clearly stated in the chronicles of the Taku clan, another offshoot of the Nabeshima clan, which was in virtual control of Arita-Sarayama. In other words, the Nabeshima clan kiln at Ōkawachi-yama produced celadon and underglaze cobalt-decorated porcelain, while overglaze enamel decoration was fired at Arita-Sarayama.

Overglaze enamel techniques are not described in any of the surviving old documents. It is recorded, interestingly, in the chronicles of the Taku clan, that when the Nabeshima clan requested that enamel artisans come to Ōkawachi-yama to produce enameled porcelains for the clan, all the artisans' houses got together and signed a statement to the effect that since the art of overglaze enamels was their unrivaled, inimitable, sacred profession, no artisan should be allowed to practice it outside their community. They added, however, that they would be happy to offer their services and fire pots for the Nabeshima clan in Arita itself.

There is nothing surprising about this. Enamels mixed by the Imaizumi family were first brought to Ōkawachi-yama, where the overglaze enamels were painted on the pieces; the painted pieces were then carefully packed and transported to the enamel artisan's area of Arita, where they were fired in enamel kilns. When the firing was completed, the wares were taken to Ōkawachi-yama, escorted and guarded by vigilant clan officials.

Of course it was both troublesome and costly to transport these pots for firing in this manner. It may be wondered, therefore, why such a complicated process was created and tolerated. Toward the end of some old documents of the Taku clan, it is stated that the [Taku] clan was gratified that this secret system had been preserved to that day and expressed

the hope that it would continue. It must be understood that enameled Nabeshima pieces were made only on special order on rare occasions; they were not part of the ususal Nabeshima production.

Each enamel artisan's house had its own secret tradition in the art of mixing enamels. Special techniques were also involved in firing the enamel kiln. It is not clear when or how this tradition of preserving technical secrets developed, though it is known that at Arita-Sarayama the Nabeshima clan enforced the strict ruling that no single artisan could engage in both forming pots and overglaze enamel decoration, some authorities feel that all techniques were performed at the clan kiln. I dispute this opinion and still adhere to the theory that enameled Nabeshima was fired by the enamel artisans at Arita-Sarayama who were in the service of the clan.

The second period, the Nangawara-yama kiln period, came before the establishment of the eleven houses of specialist enamel artisans. In those days, all types of porcelain were produced freely by any Arita potter, including both those in Chinese style and other brilliantly enameled, Kutani-style pieces. This fact invites one to wonder what kind of porcelain the earliest enameled Nabeshima was. It is no doubt difficult to find an answer to this question, but it must be answered sooner or later.

Categories and Characteristics of Nabeshima Porcelain

Celadon

As the history of Nabeshima porcelain shows, this ware started out as celadon. Today, Nabeshima celadon does not attract much attention, but at that time, when the rich celadons of China captured the fancy of the Japanese, there was great demand for domestic production of this ware. This demand must be the reason why the Nabeshima kilns first produced celadon.

The early production centered around a Chinese variety known in Japan as *kinuta* celadon. Later, Nabeshima celadon also included a type of Chinese crazing effect.

Rust-Brown (*Sabi*) Nabeshima

Since the raw material for a rust-brown (*sabi*) glaze existed at Ōkawachi-yama, this glaze naturally came to be used on Nabeshima porcelain. This rather dark rust color harmonizes well with celadon and cobalt.

Azure (*Ruri*) Nabeshima

Occasionally, pieces displaying an azure glaze were made. The same cobalt as used for underglaze decoration was employed, but, rather than paint the cobalt on as a pigment (the usual underglaze process), cobalt was mixed with glaze and poured onto the piece. There are both dark and light azure glazes; the light azure glaze is found on Nabeshima pieces of high quality.

Indigo (*Ai*) Nabeshima

The term indigo (*ai*) Nabeshima is just a synonym for underglaze cobalt decorated porcelain, or "blue-and-white," as it is sometimes known. Most of the production of the Nabeshima clan kiln was celadon and this indigo ware. This has been verified by the fact that excavations made at sites where flawed pieces were buried have revealed primarily these two types.

Underglaze cobalt decorated porcelain was produced continuously over a long period. Later works generally are not very impresseve, but those produced during the Genroku and Kyōhō periods—the golden age of Nabeshima ware—are for the most part superb.

Enameled Nabeshima (*Iro-Nabeshima*)

Brightly colored porcelains decorated with overglaze enamel are referred to as Iro-Nabeshima. This term literally translates as "colored" Nabeshima, but this ware is referred to here more accurately as enameled Nabeshima. These pieces were specially produced to be presented to the shogun and to other clan lords. Compared with cobalt-decorated and celadon wares, enameled Nabeshima was produced in much smaller quantities and in fewer types. During the two hundred years of Nabeshima's productive and creative activity, only about seventy designs for 7-*sun* (21 cm; 1 *sun* is 3.03 cm) dishes; about sixty designs for 5-*sun* (15 cm) dishes; and twenty-five designs for large dishes are known to have been made. Not many of these have survived to the present day, and it is extremely difficult now to find a 7-*sun* enameled Nabeshima dish; this serves to emphasize the fact that these colorful pieces were produced for special purposes only for the lord of Nabeshima.

Features of Nabeshima Porcelain

One important feature of Nabeshima porcelain is the standardized forms of the pieces. Some form varia-

tions are found in earlier, small dishes, but from the golden age onward, the majority of objects produced were footed dishes standardized into 3-, 5-, 7-, and 10-*sun* sizes (10 *sun* equal 1 *shaku*; the latter are also called *shaku bachi—shaku* dishes). The shape of these is like the wide, shallow cups used for saké. Their execution is brilliant, and the curves are elegant.

A unique feature of Nabeshima ware is a cobalt-blue comb-tooth pattern that appears on the foot rims of many dishes. The vertical stripes of this pattern had to be calculated so that each stripe was the same size and the spaces between stripes were uniform—that is, the last stripe painted had to match with and be the right distance from the first one. The skill required to paint this seemingly simple pattern took long years of experience.

Thus, a look at this comb-tooth pattern reveals at a glance the quality of workmanship of a piece and also something of the age in which it was produced. The more recent the pieces, the poorer the quality of the comb-tooth pattern workmanship. The purpose of painting these comb-tooth patterns must surely have been to demonstrate the high level of skill involved in making Nabeshima ware.

On the foot rims of earlier pieces, "heart" patterns and lattice patterns are also found; on 1-*shaku* dishes, besides the comb-tooth pattern, the interlocking circle (*shippō*) pattern is found, but in general the comb-tooth pattern is by far the most frequently encountered. Dishes of the 7-*sun* size were more often than not made in sets of twenty or thirty pieces, all of which were coordinated in design, an elaborate feat that certainly must have drawn upon the skill of the potter and designer.

On the underside of the dishes, interlocking circle (*shippō*) and floral scroll patterns are common. There are, of course, other designs, particularly floral ones. These underside patterns were executed in great detail, and this in itself is an important characteristic of Nabeshima ware.

Designs on the upper surface of the dishes can be classified in two categories—pictorial and patterned. The pictorial type has, in most cases, flowers and other decorative motifs depicted strongly in the central area of the dish. The patterned type shows intricate patterns painted with astonishing precision and detail. Many dishes feature a combination of these two types, successfully blended into a single elegant, harmonious design.

Many of the pictorial designs were adaptations from designs found in illustrated books of the day, such as the *Ehon seisho-chō* (roughly, "Beautiful Drawing") and the *Ehon noyamagusa* ("Wild Flowers and Plants Illustrated"), which correspond to pattern or design sample books or practice books for painters. Designs of the patterned type were sometimes based on textile designs or on Nō theater costume. It is thought that patterns and designs in vogue at various times were used as sources of inspiration.

Besides footed dishes, other forms were small, deep bowls, saké cups, vases, tea ceremony water containers, incense burners, and so on, but such pieces account for only an insignificant part of the overall production.

By far the most important characteristic of overglaze enameled Nabeshima is the elegance and brilliance of the colors. Using only three enamel colors—red, green, and yellow—besides cobalt underglaze, the designers successfully created marvelous effects of rhythm and harmony. There are also, incidentally, a few rare pieces using black and gold.

Red enamel comes in several tones, ranging between a purplish red and vermilion, but each red without exception is clear and strong.

The green used on Nabeshima porcelain is called "thin green" and is rather bluish in tone, with a unique and arresting sense of depth. It is very difficult to create this color, and few today have successfully reproduced it. This "thin green" of enameled Nabeshima is soft in outline, compared to the usual crisp enamel outline, and the familiar enamel gloss is absent. This is the way to determine whether a given piece is authentic Nabeshima or not, a point that should be borne in mind in studying works of porcelain.

The yellow enamel on Nabeshima is understated and subdued. Bright yellow could be an indication of recent origin.

The enamel artisans made great efforts in the selection and mixing of raw materials and in the firing of the enamel to produce colors that would be unique to Nabeshima. Since enameled Nabeshima is characteristically covered with a thick clear glaze, the background displays a bluish tint, which gives a quiet tone to the cobalt blue designs. But the powerful enamel colors, when painted on this subdued cobalt design, create an indescribable harmony. The artistry is of rare excellence. The

brushwork of the master enamel painters gives life to every line.

Blue-and-white pieces, too, feature powerful brushwork, although the lines are thin and delicate—this is one feature that should be looked for. Pieces done after the Bunka period (1804–18), however, show signs of technical decline.

Problems of Nabeshima Today

As described above, Nabeshima porcelain is best represented by enameled Nabeshima, with its glorious colors, powerful design composition, and impeccable workmanship.

There have, however, been some critical comments voiced about Nabeshima porcelain. One such observation states that, because of their technical perfection, Nabeshima pieces are rigid, with little room for artistic freedom. It is quite correct that Nabeshima pieces were made in strict conformity with specifications given by the clan authorities and were the result of organized collective craftsmanship. There was indeed no room for artists to freely give expression to their creative flair or for individual potters to experiment with various glaze and form combinations. This sort of artistic freedom was alien to the world of traditional craftsmanship.

Quality porcelain such as that of Nabeshima cannot be manufactured by one person. Neither in the East nor in the West in antiquity are there any great works of porcelain ascribed to a single artist. This is true of the antique porcelain of China, the greatest land of ceramic art. Thus we can say that the production of Nabeshima porcelain was possible because potters and painters of unrivaled excellence were brought together to work on given assignments with generous financial support and were thus free from all distracting preoccupations. This point must be understood well for the superb qualities of this ceramic art to be properly appreciated.

Following transfer of the kiln to Ōkawachi-yama, Nabeshima porcelain continued to be produced for almost two centuries, but few pieces dating from this period survive today. In fact, there are so few of them today that one wonders if the production figure of five thousand or more pieces per annum advanced by some researchers can in fact be true.

Saggers were not known in those days, and even at the technically advanced clan kiln, potters had no choice but to use the climbing kiln in a rather inef-

ficient manner. Given the technical level of the day, the yield rate of successfully fired pieces must have been less than 50 percent. Flawed pieces were all buried.

Another point that comes to mind in connection with this is that each piece demanded so much handwork that any kind of mass production must have been completely out of the question. This makes it possible to speculate that far fewer pieces may have been produced than has been supposed. It is precisely this rarity that explains the jealousy with which the few surviving pieces have been treasured.

One interesting undertaking is to review the history of the Nabeshima clan's kiln operation from the economic standpoint. None of the pieces was ever sold. They were, as stated earlier, all made as gifts to the shogun, to the daimyos of other clans of the day, and for the clan's own household use. The entire running of the kiln must have been quite costly.

It is reasonable to suppose that expenses must have been covered by the taxes levied from Arita-Sara-yama. When its financial state was favorable during the Genroku and Kyōhō periods, the clan poured abundant funds into kiln and workshop to ensure that quality articles were produced. As the clan's finances began to decline, however, less concern was given to the production of quality porcelain. This tendency became increasingly clear in the post-Bunka periods.

The Nabeshima clan's prosperity was already a fact of the past when the newly instated Meiji government replaced the feudal fief system with the prefectural administrative system. With this, of course, came the end of the Nabeshima clan kiln. But many regretted seeing the glorious craft tradition disappear into oblivion, and the tenth-generation Imaemon rose to fight for the preservation of the priceless heritage.

The generations of the Imaizumi family had been, as seen above, master painters of enameled Nabeshima porcelain. To meet the challenge of preserving Nabeshima porcelain, the family had to learn forming and firing techniques as well. This task took long years, with many failures and learning something from each of them.

Through the Taishō years (1912–25) in particular, under the eleventh-generation Imaemon, severe hardships were encountered. All kiln operators at Arita, too, were hard hit. It was not until after the Shōwa period (1926–) that, under the guidance of the

twelfth-generation Imaemon, the strenuous efforts of many years began finally to bear fruit. After the father-son team of Imaemon XI and the future Imaemon XII had begun to work together, they started to produce high-quality pieces. It appeared that, at long last, they had succeeded in bringing back to life the long-forgotten technique of enameled Nabeshima. Today, the preservation of this technique is sponsored by the Japanese government, which has designated it an "Important Intangible Cultural Property."

We are entering the age of Imaemon XIII, who faces the difficult task of creating new values while standing in the light of his splendid tradition. It is strongly hoped that his dedication will result in a continuation of the same standards of his forbears while contributing the vigor of original, modern artistry.

EARLY NABESHIMA FOOT RIM EXAMPLES

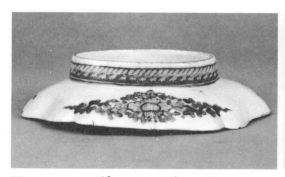

Wave pattern (foot rim, Plate 45)

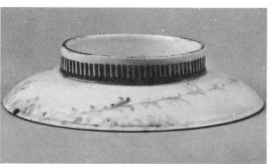

Comb-tooth pattern (foot rim, Plate 46)

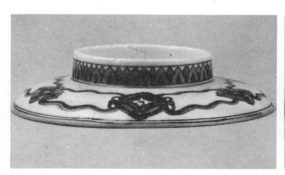

Blade pattern (foot rim, Plate 47)

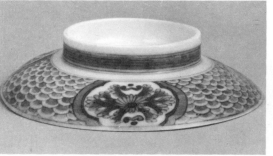

Thunder pattern (foot rim, Plate 51)

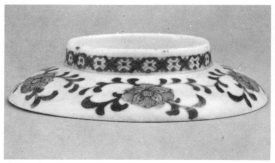

Lattice pattern (foot rim, Plate 53)

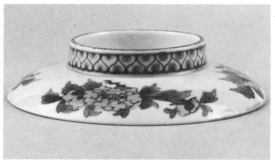

Heart pattern (foot rim, Plate 54)

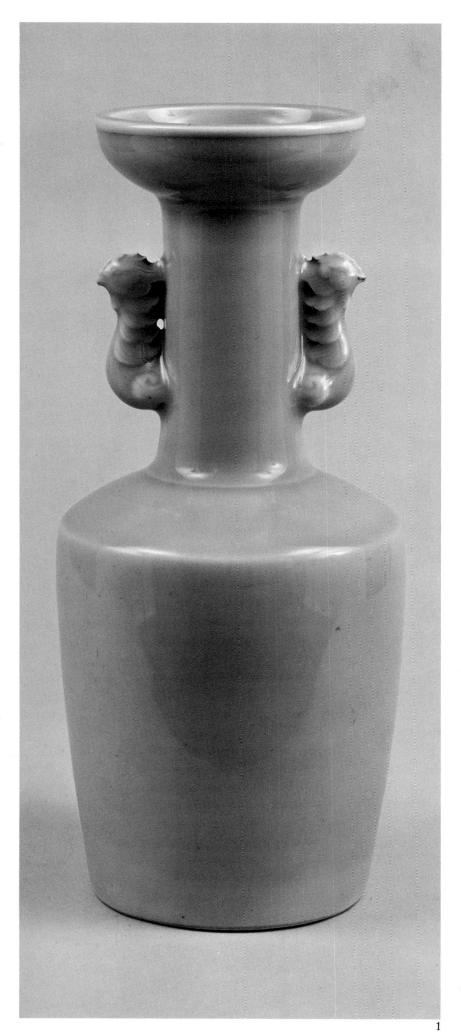

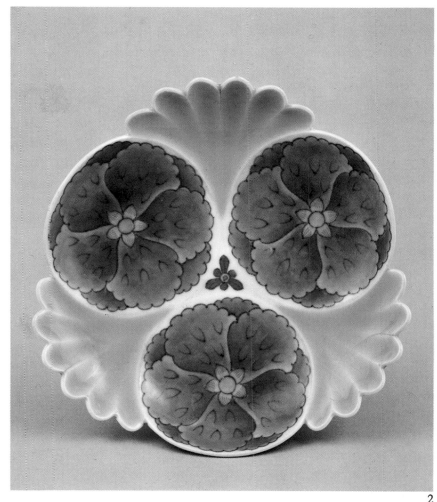

Celadon

1. *Celadon vase with phoenix ears. H. 28.9 cm.*

2. *Celadon and cobalt eccentric dish, cotton rose design. D. 14.9 cm. Imaemon Antique Ceramics Center.*

3. *Celadon water container after the Chinese Jiao-tan guan-yao style. H. 17.5 cm.*

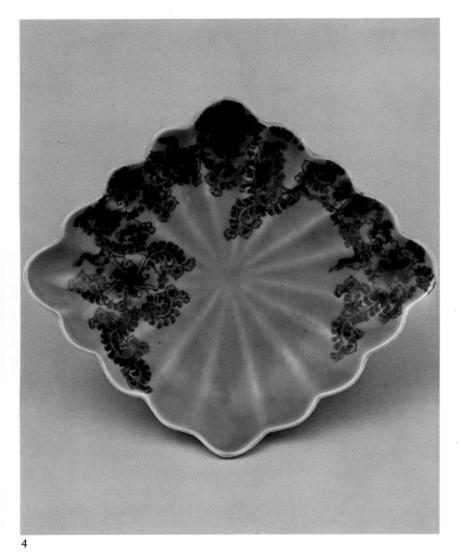

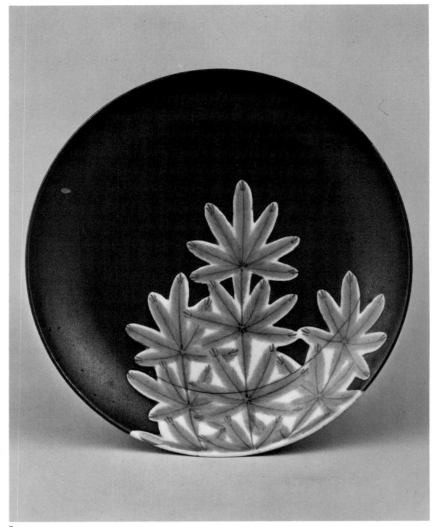

4

5

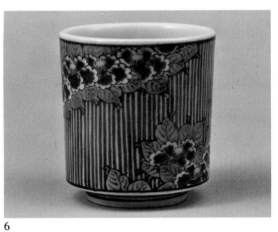

6

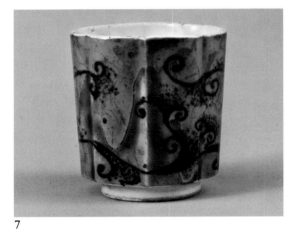

7

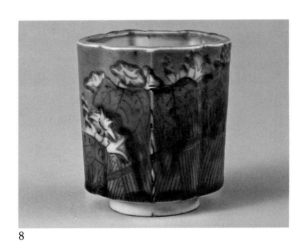

8

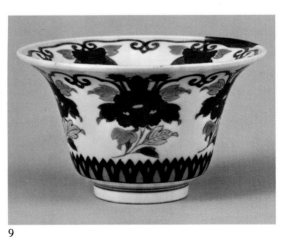

9

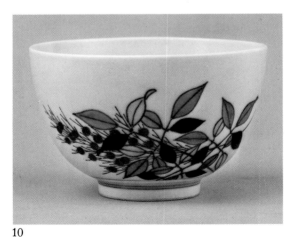

10

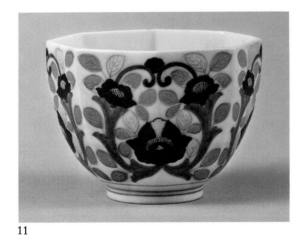

11

4. *Pale azure lobed dish, floral scroll pattern. 17.5 × 15.2 cm. Imaemon Antique Ceramics Center.*

5. *Cobalt and rust-glazed 5-sun dish, pine design. D. 15.9 cm. Imaemon Antique Ceramics Center.*

6. *Enameled Nabeshima cup, camellia wreath design. H. 6.7 cm. Imaemon Antique Ceramics Center.*

7. *Early enameled Nabeshima cup, stylized mountains and waves design. H. 6.4 cm.*

8. *Early enameled Nabeshima cup, morning glory design. H. 6.3 cm.*

9. *Enameled Nabeshima small serving dish, floral scroll design. H. 6.4 cm. Imaemon Antique Ceramics Center.*

10. *Enameled Nabeshima small bowl, nandina design. H. 6.5 cm.*

11. *Enameled Nabeshima octagonal cup, floral scroll pattern. H. 5.8 cm. Imaemon Antique Ceramics Center.*

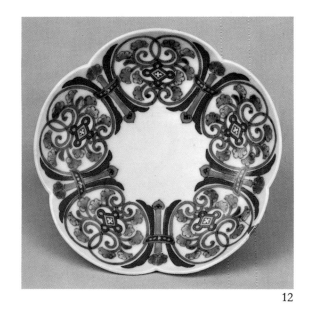

12

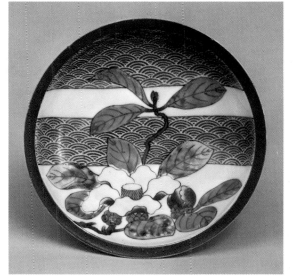

13

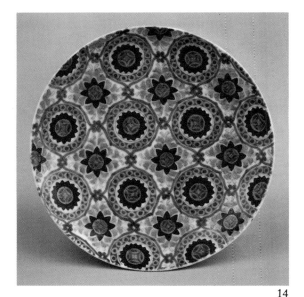

14

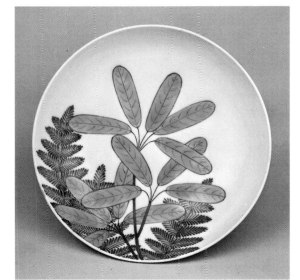

15

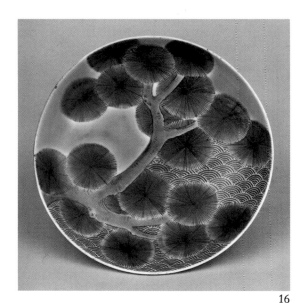

16

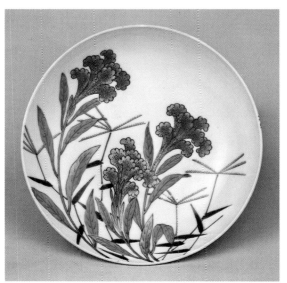

17

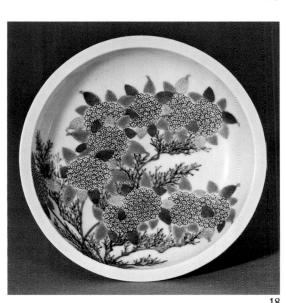

18

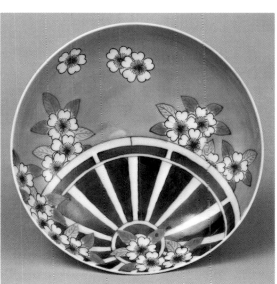

19

12. *Enameled Nabeshima 5-*sun *dish, plum-blossom form, floral pattern. D. 15.4 cm. Okayama Art Museum.*

13. *Enameled Nabeshima 5-*sun *dish, camellia design. D. 15.0 cm. Okayama Art Museum.*

14. *Enameled Nabeshima 5-*sun *dish, patterned design. D. 15.1 cm. Okayama Art Museum.*

15. *Enameled Nabeshima 5-*sun *dish, yuzuri design. D. 14.7 cm. Okayama Art Museum.*

16. *Cobalt and celadon 5-*sun *dish, pine tree design. D 14.9 cm. Okayama Art Museum.*

17. *Enameled Nabeshima 5-*sun *dish, cockscomb design. D. 14.7 cm. Okayama Art Museum.*

18. *Enameled Nabeshima 5-*sun *dish, hydrangea design. D. 15.0 cm.*

19. *Enameled Nabeshima 5-*sun *dish, flowers and wheel design. D. 15.0 cm. Kurita Art Museum.*

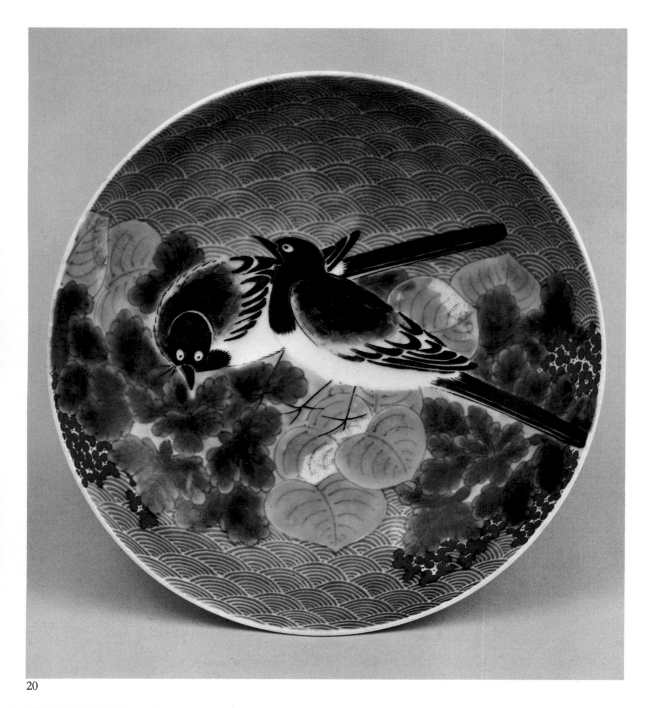

20

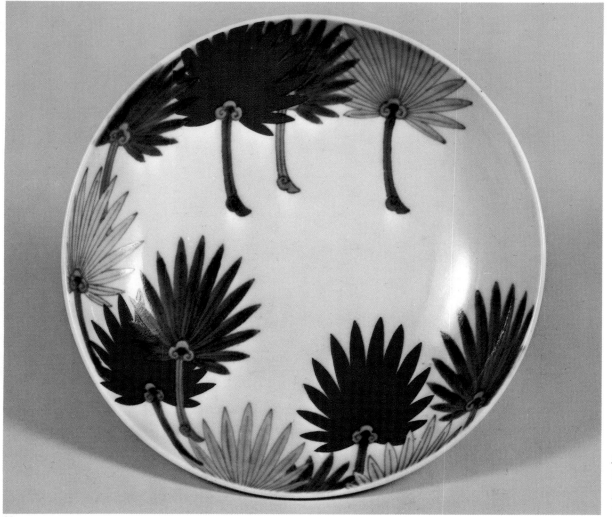

21

20. Enameled Nabeshima 5-sun dish, wagtail design. D. 15.0 cm. Okayama Art Museum.

21. Enameled Nabeshima 5-sun dish, palm leaf design. D. 14.8 cm. Kyūsei Atami Art Museum.

16

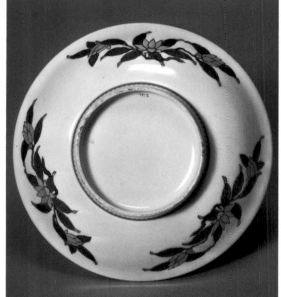

22

23

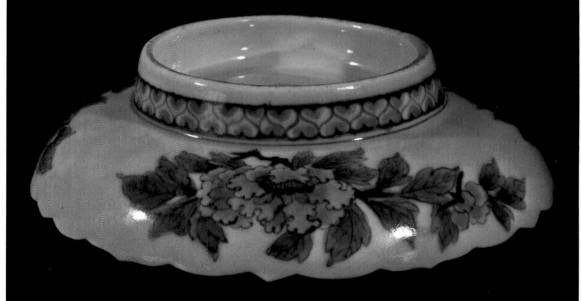

24

25

22, 23. *Underglaze cobalt 7-sun dish, floral pattern. D. 20.7 cm.*

24, 25. *Underglaze cobalt 7-sun dish, Chinese floral pattern in relief. D. 19.0 cm. Museum of Ethnology, Leiden.*

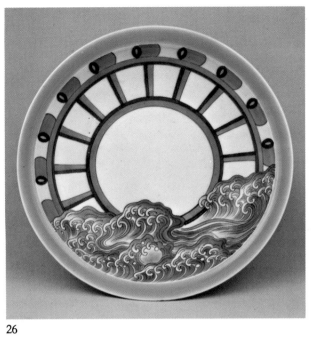

26

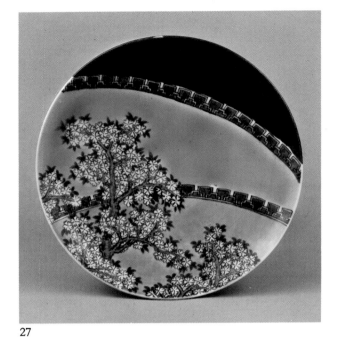

27

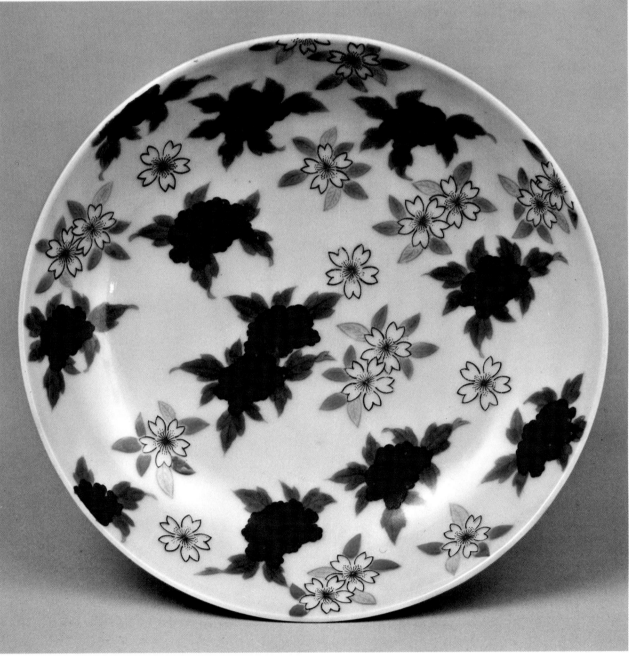

28

ENAMELED 7-*sun* DISHES

26. *Cobalt and celadon 7-sun dish, waterwheel and wave design. D. 20.5 cm. Tanakamaru Collection.*

27. *Cobalt, celadon, and rust glaze 7-sun dish, cherry blossom design. D. 19.7 cm.*

28. *Enameled Nabeshima 7-sun dish, peony and cherry blossom pattern. D. 19.3 cm.*

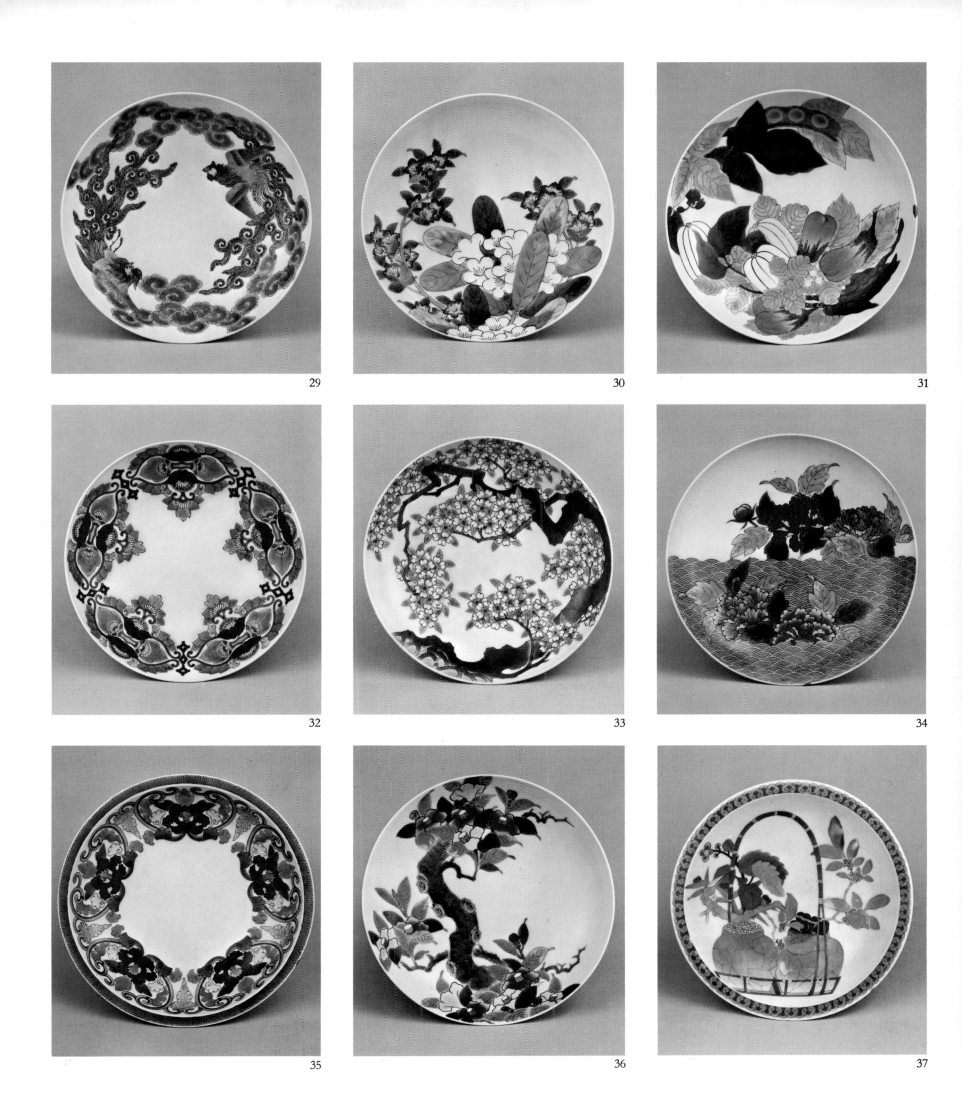

29 30 31

32 33 34

35 36 37

29. Enameled Nabeshima 7-sun dish, phoenix design. D. 19.8 cm.

30. Enameled Nabeshima 7-sun dish, rhododendron design. D. 20.3 cm.

31. Enameled Nabeshima 7-sun dish, vegetables design. D. 20.3 cm.

32. Enameled Nabeshima 7-sun dish, floral pattern. D. 19.9 cm. Imaemon Antique Ceramics Center.

33. Enameled Nabeshima 7-sun dish, cherry blossom design. D. 20.4 cm. Tokyo National Museum.

34. Enameled Nabeshima 7-sun dish, peonies and ocean wave design. D. 19.8 cm.

35. Enameled Nabeshima 7-sun dish, peony and scroll pattern. D. 20.5 cm. Okayama Art Museum.

36. Enameled Nabeshima 7-sun dish, camellia design. D. 20.2 cm.

37. Enameled Nabeshima 7-sun dish, flowers and jars design. D. 19.5 cm. Okayama Art Museum.

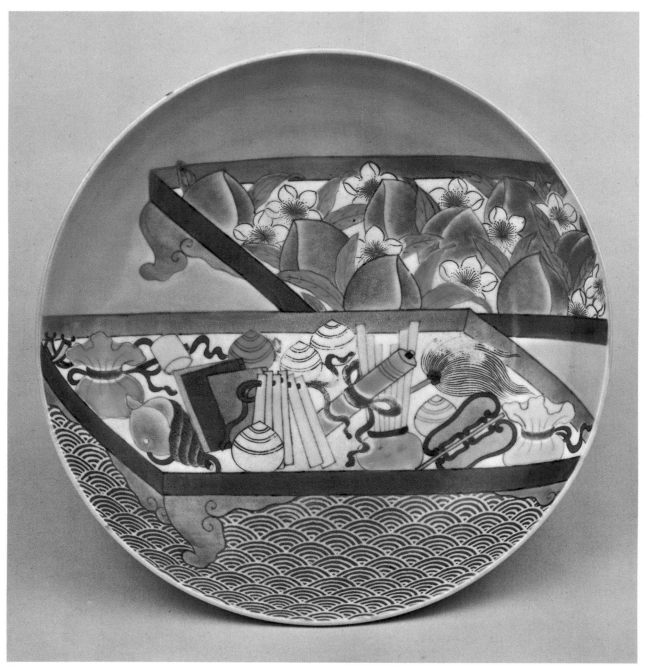

38

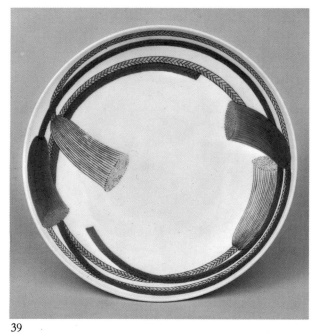

39

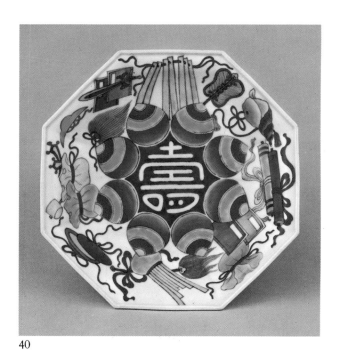

40

38. *Enameled Nabeshima 7-sun dish, peaches and treasures design. D. 20.0 cm. Imaemon Antique Ceramics Center.*

39. *Enameled Nabeshima 7-sun dish, braided cord design. D. 20.3 cm. Okayama Art Museum.*

40. *Enameled Nabeshima octagonal dish, treasures design. 21.0 × 19.6 cm. Imaemon Antique Ceramics Center.*

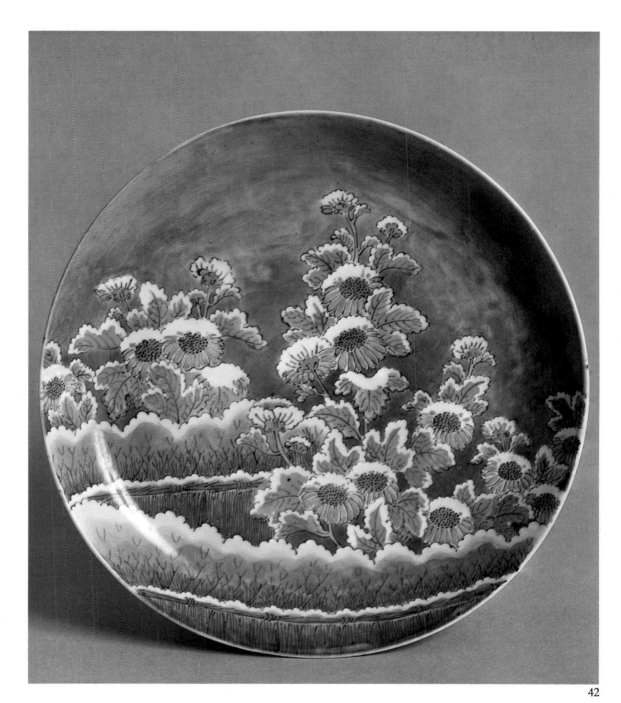

41

42

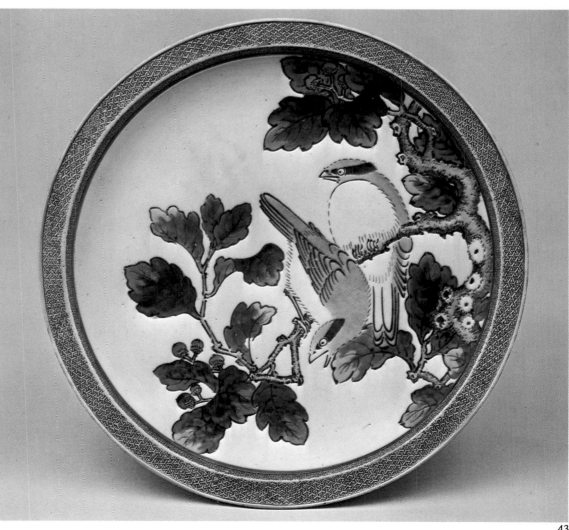

41, 42. *Early enameled Nabeshima large dish, snow and chrysanthemums design. D. 25.7 cm. Bauer Collection, Geneva.*

43. *Early enameled Nabeshima large dish, oak and birds design. D. 30.0 cm.*

43

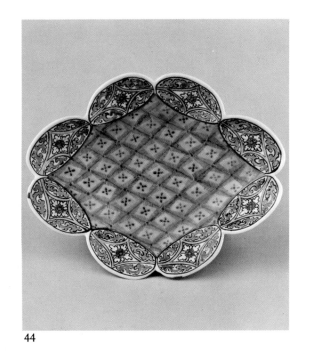
44

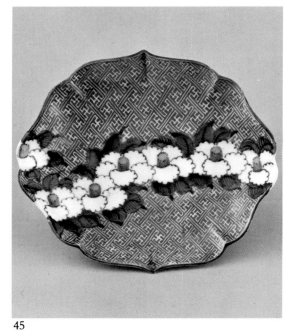
45

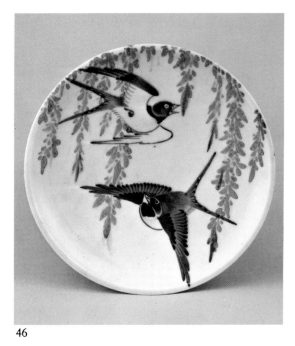
46

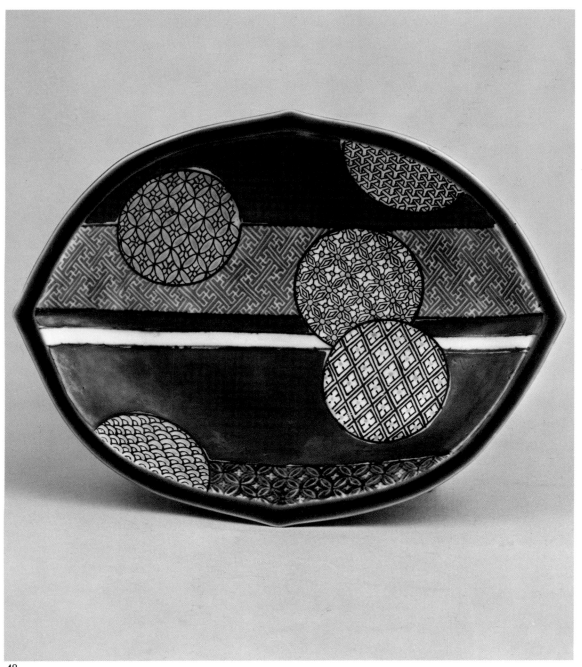
48

47

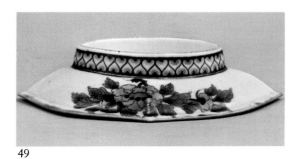
49

Early Nabeshima Dishes

44. Early enameled Nabeshima lobed dish. 16.3 × 13.0 cm. Imaemon Antique Ceramics Center.

45. Early enameled Nabeshima dish, camellia chain design. 15.2 × 13.2 cm. Imaemon Antique Ceramics Center.

46. Early enameled Nabeshima 5-sun dish, willow and swallows design. D. 15.6 cm. Imaemon Antique Ceramics Center.

47. Early enameled Nabeshima 5-sun dish, textile print pattern. D. 15.0 cm.

48, 49. Early enameled Nabeshima dish, rust glaze ground. 16.8 × 12.8 cm. Tokyo National Museum.

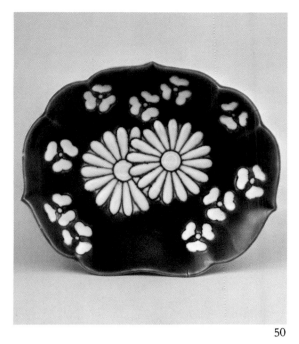

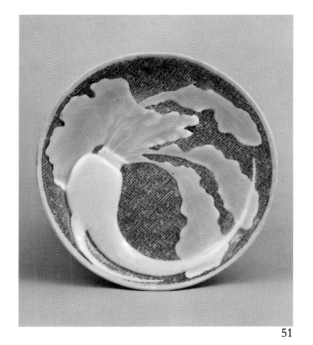

50

51

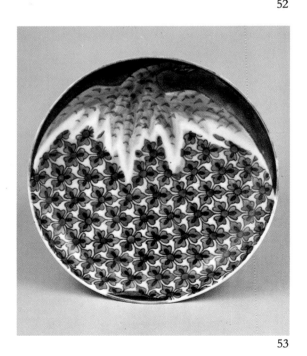

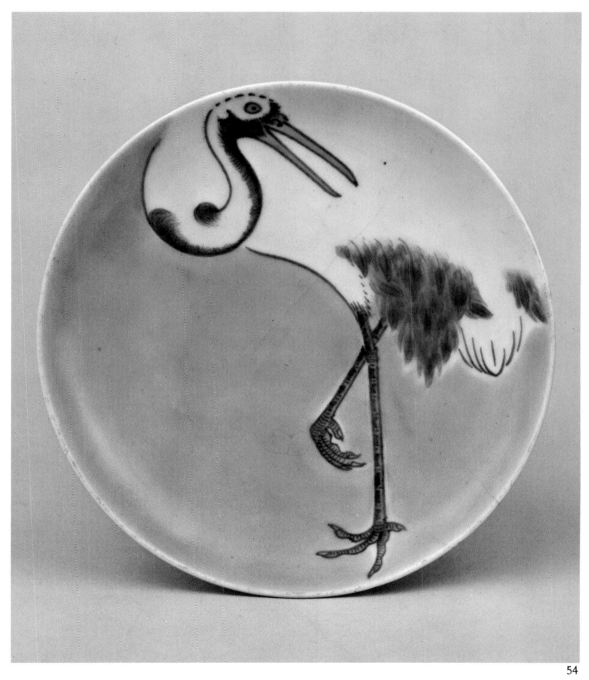

52

53

54

50. *Early Nabeshima dish, azure glaze, chrysanthemum design. 15.0 × 12.5 cm.*

51. *Early Nabeshima dish, celadon and cobalt, radish design. D. 15.7 cm.*

52. *Early Nabeshima 5-sun dish, cobalt and celadon, floral pattern. D. 15.2 cm.*

53. *Early Nabeshima 5-sun dish, cobalt and rust glaze, eggplant motif and floral pattern. D. 15.3 cm.*

54. *Early Nabeshima dish, cobalt and celadon, crane design. D. 15.4 cm. Imaemon Antique Ceramics Center.*

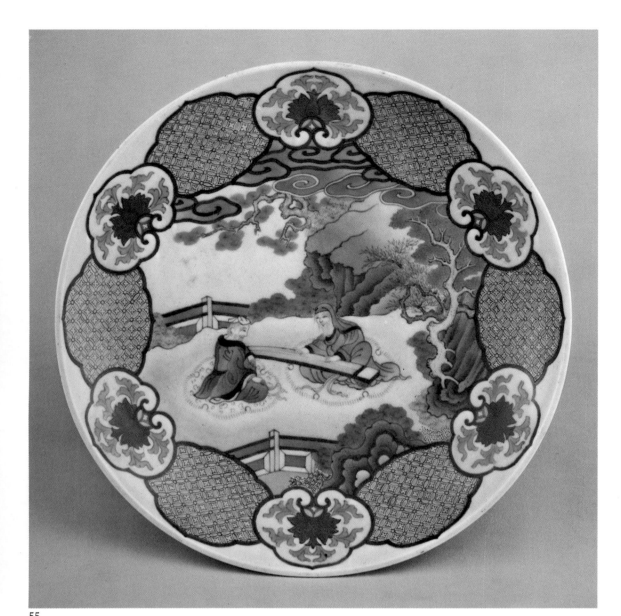

55

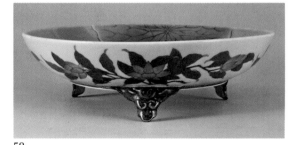

56

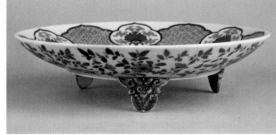

58

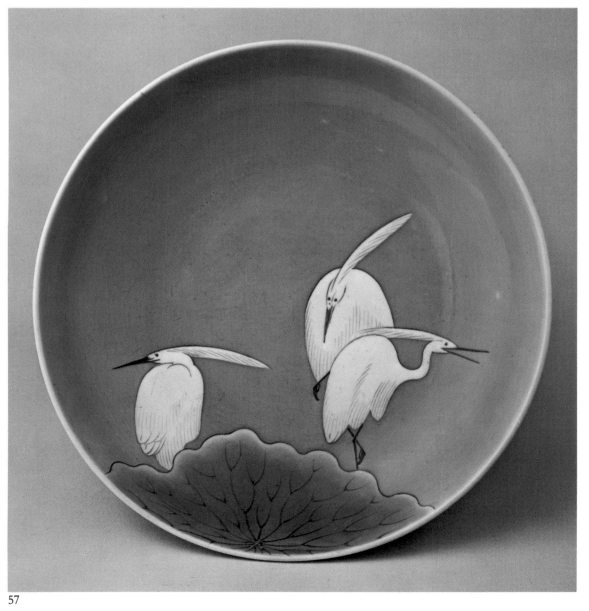

57

55, 56. *Three-legged enameled dish, design of playing the koto under a pine. D. 28.5 cm.*

57, 58. *Three-legged cobalt-decorated dish, heron design. D. 28.0 cm.*

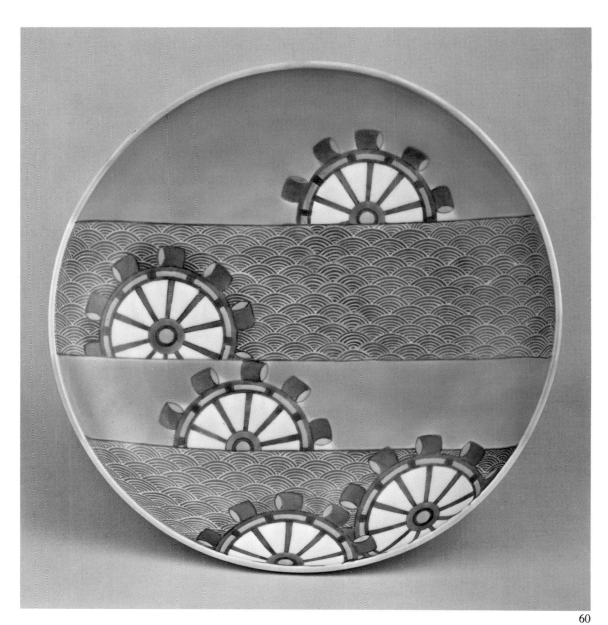

60

59

61

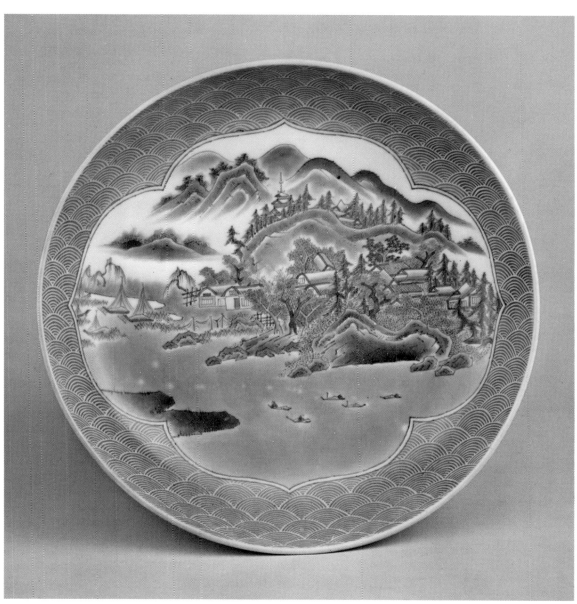

62

59, 60. Large dish, celadon and cobalt, waterwheel and wave design. D. 30.3 cm. Imaemon Antique Ceramics Center.

61, 62. Large dish, cobalt landscape design. D. 30.5 cm.

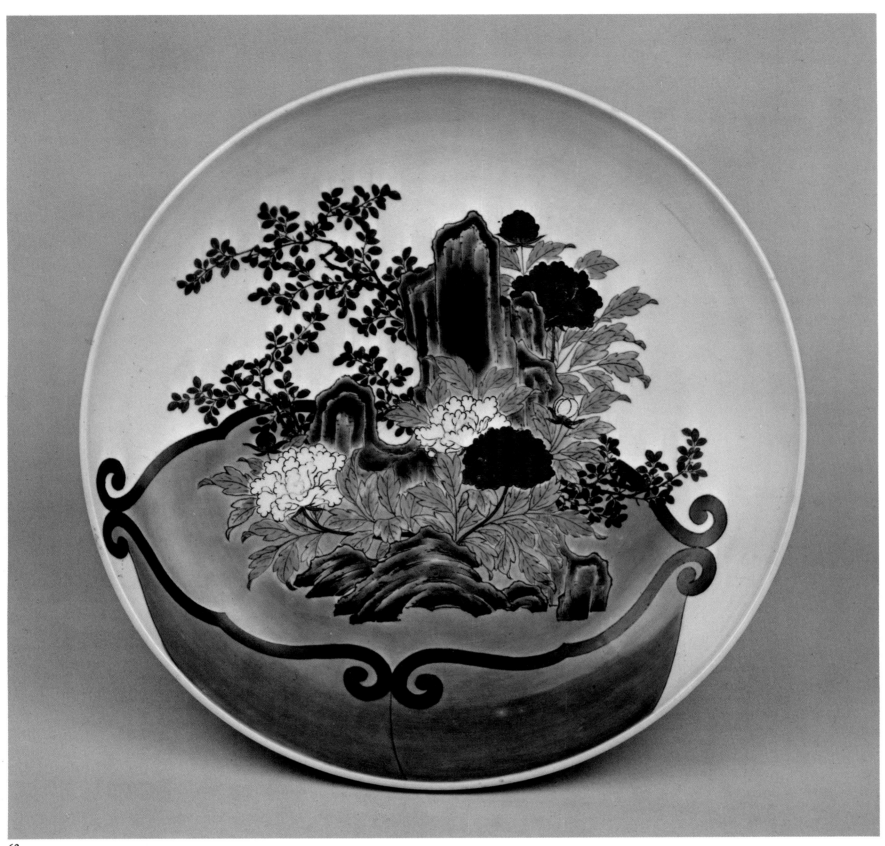

63

64

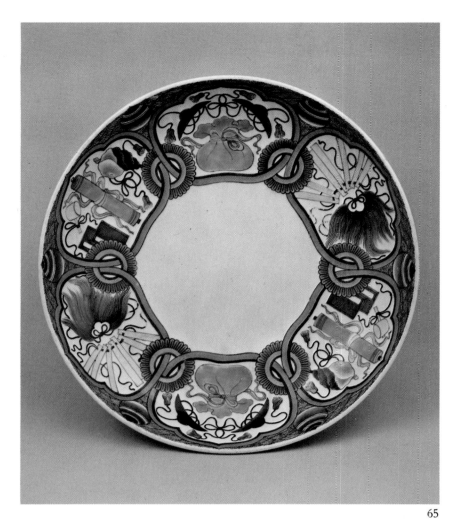

65

66

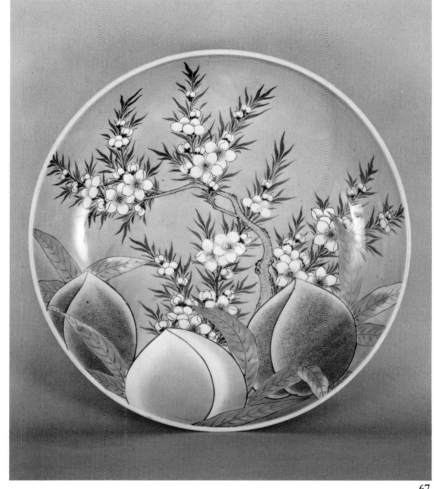

67

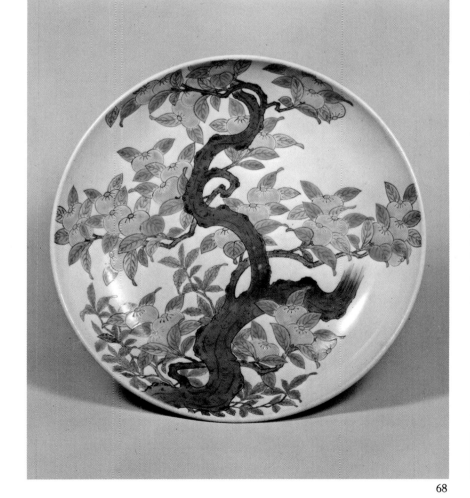

68

LARGE ENAMELED DISHES

63, 64. (facing page) Large enameled Nabeshima dish, peony, rock and flowerpot design. D. 30.9 cm. Kurita Art Museum.

65, 66. Large enameled Nabeshima dish, treasures design. D. 30.3 cm. Okayama Art Museum.

67. Large enameled Nabeshima dish, peach design. D. 31.7 cm. Kyūsei Atami Art Museum.

68. Large enameled Nabeshima dish, mandarin orange design. D. 30.0 cm. Kyūsei Atami Art Museum.

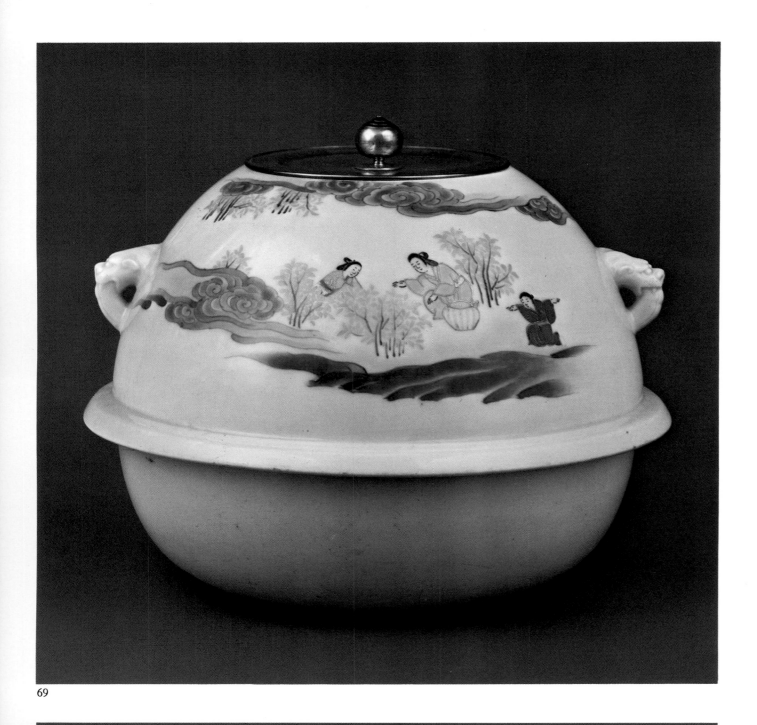

69

69. Enameled Nabeshima container in the shape of a tea ceremony hot water kettle, design of tea picking. H. 17.8 cm. Tanakamaru Collection.

70. Enameled Nabeshima incense stand, vine design. H. 10.8 cm.

70

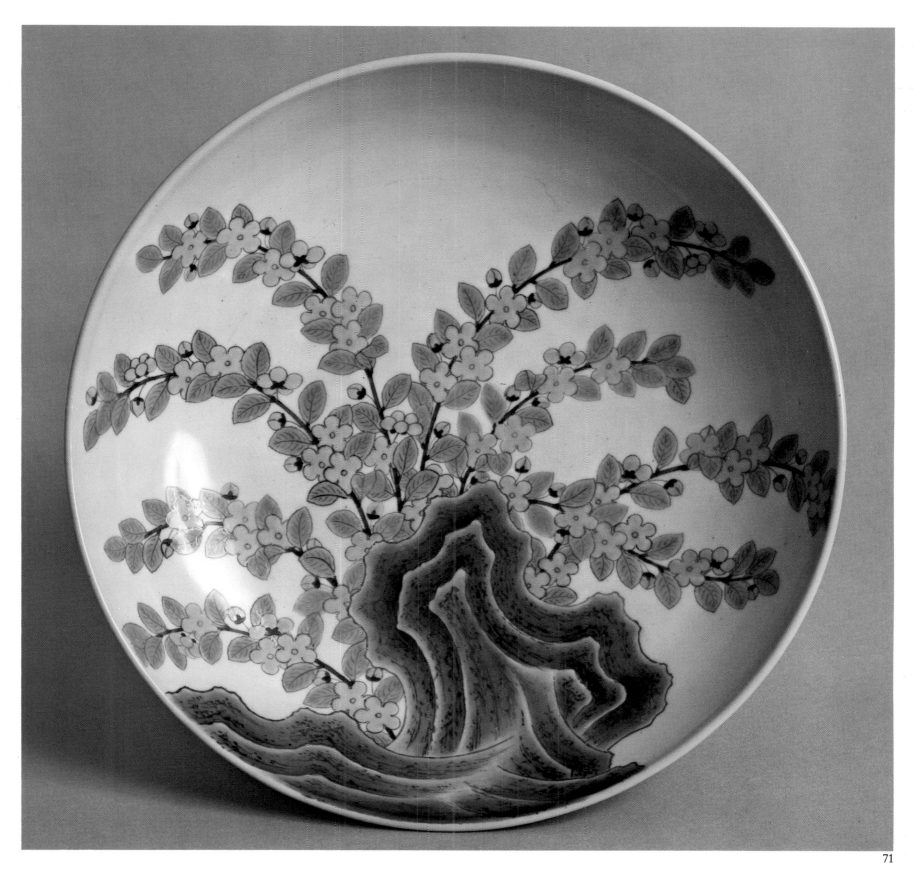

71

72

71, 72. *Large enameled Nabeshima dish, rock and kerria flower design. D. 30.8 cm. Bauer Collection, Geneva.*

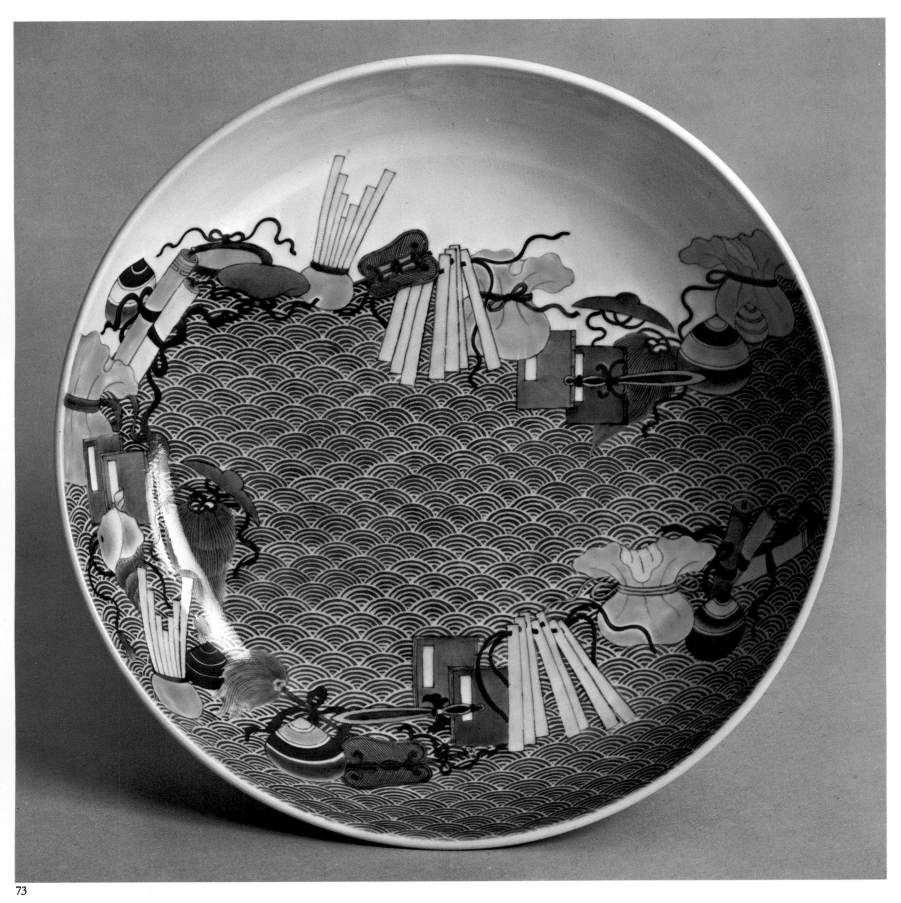

73

73, 74. *Large enameled Nabeshima dish, ocean wave and treasures design. D. 30.6 cm. Bauer Collection, Geneva.*

74

30

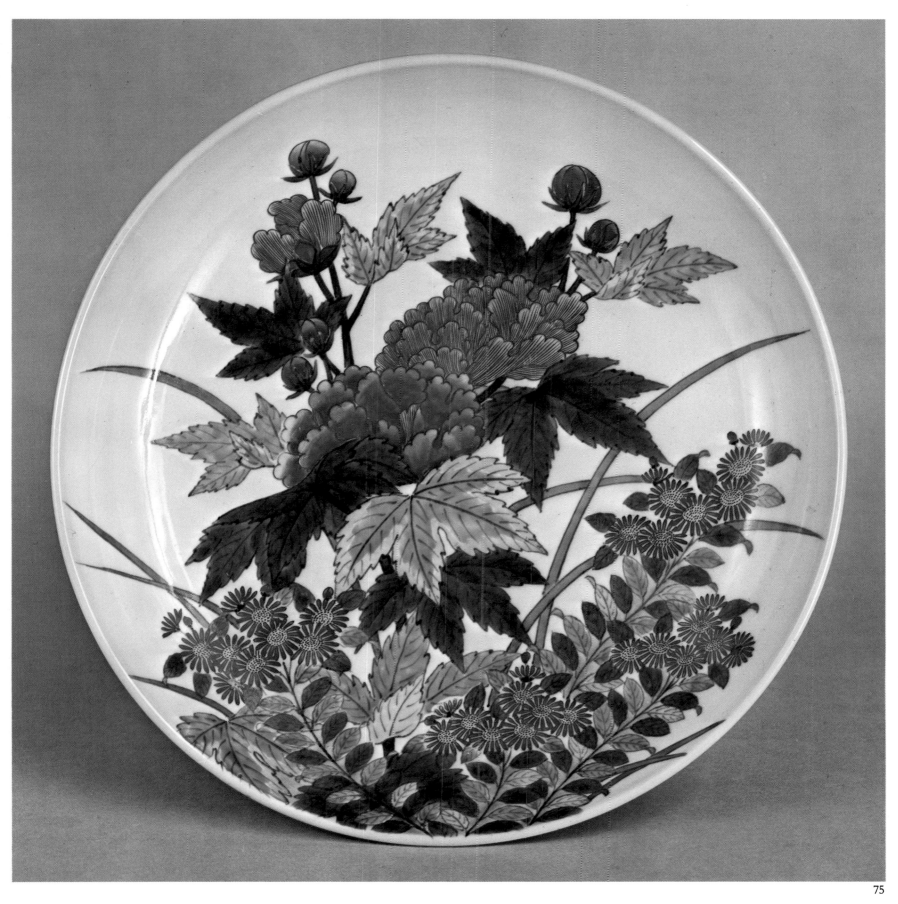

75. *Large enameled Nabeshima dish, cotton rose and chrysanthemum design. Important Cultural Property.*
D. 32.0 cm.

76. *(overleaf) Enameled Nabeshima jar, pine, bamboo, and plum design. Important Cultural Property. H.*
30.6 cm.

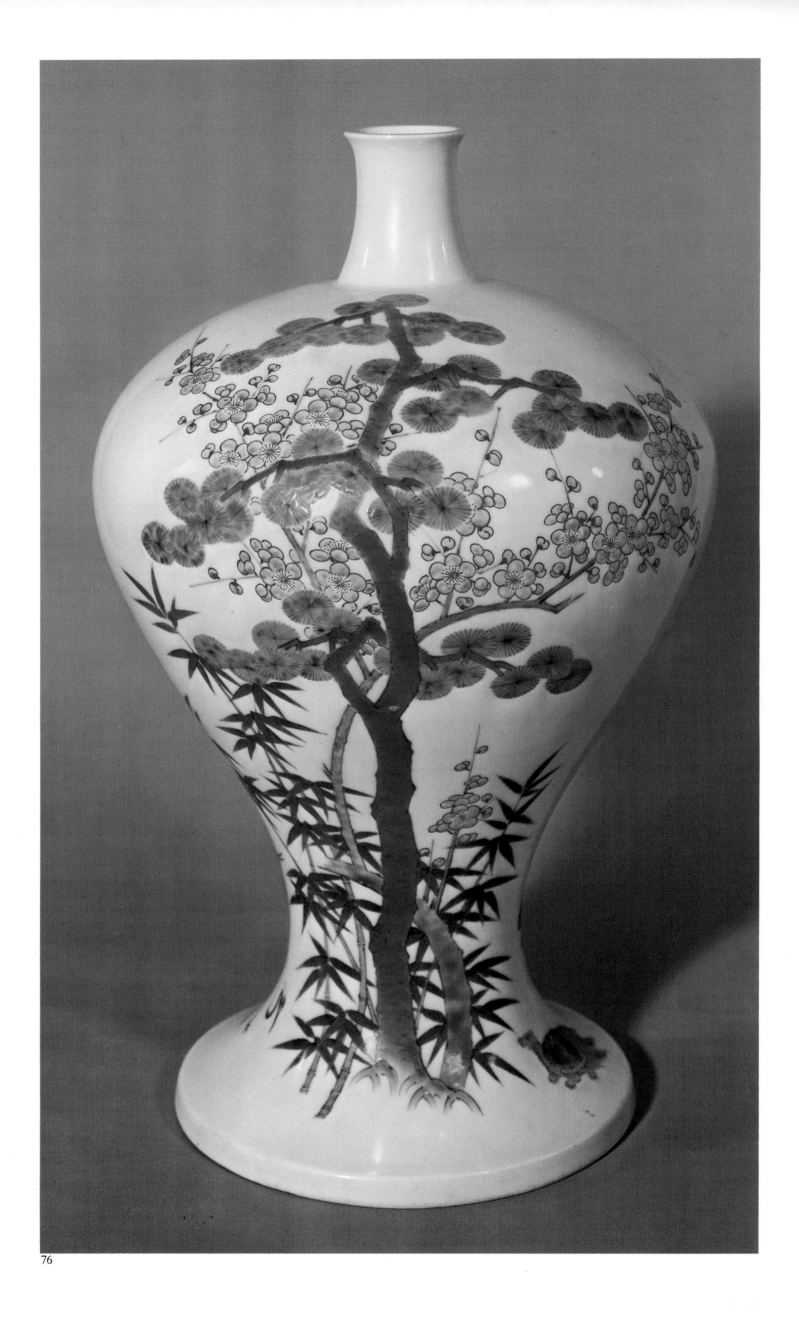

Plate Notes

1. *Celadon vase with phoenix ears. H. 28.9 cm.*
Celadon porcelain was initially the main product coming out of the Nabeshima kiln in its early days, and a number of kinds were made experimentally. It was, in fact, precisely because outstanding celadon porcelain raw material was found at Ōkawachi-yama that the kilns were transferred there from their location at Nangawara. But before perfecting the technique of bringing out the vivid green best characterized by this type of celadon, known in Japan as *kinuta,* potters at the clan kiln must have dedicated themselves to many years of trial and error. In the process, of course, many bowls, dishes, vases, and alcove ornaments were fired, and some of them are superb. One such example is shown here.

2. *Celadon and cobalt eccentric dish, cotton rose design. D. 14.9 cm. Imaemon Antique Ceramics Center.*
A 5-*sun* dish with an unusual form, this piece features a superbly elaborate design. The tone of the celadon is extremely pleasant and harmonizes well with the round cotton rose medallions done in cobalt. A truly Nabeshima-like work.

3. *Celadon water container after the Chinese Jaio-tan guan-yao style H. 17.5 cm.*
The Jiao-tan guan-yao celadon porcelain was made during the Sung dynasty in China. Few examples have survived. The pieces have been much sought after, and during the Ch'ing dynasty many imitations were made. It has also been discovered that the Nabeshima clan kiln fired its own copies of the Ch'ing dynasty imitations. Such copies were made only at the Nabeshima clan kiln, being produced for the most part during the latter half of the Ōkawachi-yama period.

4. *Pale azure lobed dish, floral scroll pattern. 17.5 × 15.2 cm. Imaemon Antique Ceramics Center.*
A rare example of a serving dish in which a pale azure cobalt glaze has been applied over both top and underside of the dish. The details of the floral scroll pattern are somewhat unclear. The piece was found in Great Britain, and nothing like it has ever been found in Japan.

5. *Cobalt and rust-glazed 5-sun dish, pine design. D. 15.9 cm. Imaemon Antique Ceramics Center.*
This piece is rare in that it has been glazed all over (including the underside) with rust glaze. The unusual quality of this 5-*sun* dish has been further enhanced by the pine branch executed in cobalt.

6–8. *Enameled Nabeshima cups, camellia wreath, mountains and waves, morning glory designs. H. 6.7, 6.3, 6.4 cm. Imaemon Antique Ceramics Center.*
The piece in Plate 8 is so richly colored that the thick enamel appears ready to flow down the side of the pot. The cup in Plate 7 is remarkable perhaps for its purple color, but it is not clear whether the design as a whole is intended to emphasize the contrasting colors of green and purple or the pictorial elements of mountains and ocean waves. These two pieces were at first thought to belong to the *Matsugatani-de* genre, but there is little doubt that they are authentic Nabeshima.

Plate 6 shows a cup with beautifully executed cobalt blue stripes forming a brushlike fence flanked by camellia flowers.

9. *Enameled Nabeshima small serving dish, floral scroll design. H. 6.4 cm. Imaemon Antique Ceramics Center.*
Technically the most sophisticated of all the small serving dishes that have been produced.

10. *Enameled Nabeshima small bowl, nandina design. H. 6.5 cm.*
This piece is here brought to public attention for the first time. Although it is not quite clear whether this is in fact a bowl or small serving dish, the beauty of the design and power of the brushwork are superb.

11. *Enameled Nabeshima octagonal cup, floral scroll pattern. H. 5.8 cm. Imaemon Antique Ceramics Center.*
A masterpiece from the golden age, with impeccable design and coloring. This piece was brought back to Japan from Great Britain after the war, and it was only then that it was realized that Nabeshima pieces still existed abroad.

ENAMELED NABESHIMA 5-*sun* DISHES
Dozens of designs of 5-*sun* enameled Nabeshima dishes appear to have been produced over the years, a fact that makes it difficult to decide which of the surviving specimens should be singled out as representative. Moreover, it has been impossible to collect all the designs made.

12. *Enameled Nabeshima 5-sun dish, plum-blossom form, floral pattern. D. 15.4 cm. Okayama Art Museum.*
As an example of the patterned type of design, this piece is considered unsurpassed in the power of its design and the strong colors.

13. *Enameled Nabeshima 5-sun dish, camellia design. D. 15.0 cm. Okayama Art Museum.*
The rust-glazed rim of the dish gives the design a harmoni-

ous, compact effect. The blue ocean wave pattern is skill-fully executed, and the composition is quite pleasant. A good example of a 5-*sun* dish.

14. *Enameled Nabeshima 5-*sun *dish, patterned design. D. 15.1 cm. Okayama Art Museum.*
Few patterned designs are as detailed as this one. Nabeshima craftsmanship of the golden age strove for quality above all else, and pieces were obviously made without much consideration for cost or time.

15. *Enameled Nabeshima 5-*sun *dish, yuzuri design. D. 14.7 cm. Okayama Art Museum.*
Yuzuri (Daphniphyllum macropodum) fern fronds are used as New Year decorations in the region of Saga in Kyushu. The tightening effect of the red strokes amidst a green and blue composition is quite remarkable.

16. *Cobalt and celadon 5-*sun *dish, pine tree design. D. 14.9 cm. Okayama Art Museum.*
A delicate balance is kept here between celadon and cobalt blue, while executing the ocean wave pattern in a truly masterly manner. A magnificent combination of design and craftsmanship.

17. *Enameled Nabeshima 5-*sun *dish, cockscomb design. D. 14.7 cm. Okayama Art Museum.*
Although the design is rather simple, the technique displayed here is quite sophisticated.

18. *Enameled Nabeshima 5-*sun *dish, hydrangea design. D. 15.0 cm.*
Earlier I was able to introduce a 7-*sun* dish identical in both composition and coloring to this, popularly known by the name of *kaki-Nabeshima* ("persimmon Nabeshima"). Cases like this are not very common, most of the Nabeshima pieces being unique.

19. *Enameled Nabeshima 5-*sun *dish, flowers and wheel design. D. 15.0 cm. Kurita Art Museum.*
Cherry blossoms with uncolored petals are scattered across the light cobalt blue ground. Both the distribution and the tones of the colors are beautiful.

20. *Enameled Nabeshima 5-*sun *dish, wagtail design. D. 15.0 cm. Kyūsei Okayama Art Museum.*
As far as the category of 5-*sun* enameled Nabeshima is concerned, this piece is without doubt the representative masterpiece. Two varieties of the same composition are known to have been made, one with an ocean wave pattern, the other without it. The wagtail design is also found on the large 1-*shaku* dishes, one of them in the Boston Museum of Fine Arts and a second in the Bauer Collection. Unfortunately, none of this size has been found in Japan.

21. *Enameled Nabeshima 5-*sun *dish, palm leaf design. D. 14.8 cm. Kyūsei Atami Art Museum*
One of the most beautifully colored among the 5-*sun* enameled Nabeshima works. The same design appears to have been used on celadon and cobalt pieces as well. Dishes of the 5-*sun* size have a disadvantage because the small diameter does not allow the design to have the same impact as a 7-*sun* dish. But this particular piece successfully

overcomes this handicap, and personally I like this one the best of all the 5-*sun* dishes I have seen.

COBALT-DECORATED 7-*sun* DISHES

22, 23. *Underglaze cobalt 7-*sun *dish, floral pattern. D. 20.7 cm.*
This piece is in Great Britain and shows a design that has not been found in Japan. It is gratifying to learn that there are still such rarities preserved to this day in various parts of the world. The design on the underside shows that this piece was made during the golden age of Nabeshima ceramics. It appears that there are still a number of rare cobalt plates to be found in Great Britain, and I look forward to discovering them and introducing them to the public in due course. Two such pieces I introduced in an earlier book were priceless rarities, also found in Great Britain.

24, 25. *Underglaze cobalt 7-*sun *dish, Chinese floral pattern in relief. D. 19.0 cm. Museum of Ethnology, Leiden*
This 7-*sun* dish comes from the collection of the Leiden Museum of Ethnology and has a design unparalled among such pieces found in Japan. It is also the first known example of a 7-*sun* Nabeshima dish with a relief pattern. A look at the underside identifies the piece as a typical Nabeshima product. This museum has in its collection three truly precious Nabeshima pieces: an enameled Nabeshima 7-*sun* dish with braided cord design (cf. Plate 39); a plate identical to the enameled Nabeshima 5-*sun* dish with wagtail design (Plate 20); and this one.

26. *Cobalt and celadon 7-*sun *dish, waterwheel and wave design. D. 20.5 cm. Tanakamaru Collection.*
This piece is famous throughout Japan, having been displayed at a number of exhibitions across the country as an example of Nabeshima celadon and underglaze cobalt. There is a reassuring harmony between the celadon and cobalt blue, the design is splendid, and the finish impeccable. It is indeed a marvel that such beautiful pieces as this were ever made! This piece, together with the 7-*sun* dish with cherry blossom design in Plate 27, outshines any other dish of its size.

27. *Cobalt, celadon, and rust glaze 7-*sun *dish, cherry blossom design. D. 19.7 cm.*
This is one of the very few examples of a dish combining rust and celadon glazes with underglaze cobalt and is the best specimen of its kind. The foot rim has a "heart" pattern with three leaf motifs, and this undoubtedly points to the fact that this is an early Nabeshima piece. Dishes of 5-*sun* size with the same design appear to have been fired in the same period.

ENAMELED NABESHIMA 7-*sun* DISHES
During the golden age of Nabeshima production, the pots mainly fired were 1-*shaku* dishes (*shaku hachi*), 7-*sun* dishes, 5-*sun* dishes, and other standard items, which represent the cream of artistic perfection in the Nabeshima tradition. All these were made with high foot rims. In the old days, pots made with high foot rims of this type were considered

to be for the upper classes, and it may have been for this reason that Nabeshima wares display this feature.

These dishes were manufactured at the command of the Nabeshima clan lord, who ordered sets of twenty or thirty pieces, which he then sent as gifts to the shogun's household, to other feudal lords, or to his own retainers. For this reason, they were made in very limited numbers. Some of the most representative 7-*sun* dishes are introduced here.

When making enameled Nabeshima, potters first produced cobalt-decorated Nabeshima and only then proceeded to make enameled versions of the same designs. Thus, one sometimes finds underglaze cobalt dishes and enameled dishes with identical designs; alternatively, one may find that pots of the same design may be enameled in slightly different ways, depending on the period in which they were produced.

28. *Enameled Nabeshima 7-sun dish, peony and cherry blossom pattern. D. 19.3 cm.*
This is the first time that this dish has been made known to the public. The cobalt blue is slightly on the dark side, while the pale green of the leaves is rather thick, so that overall this is a superbly executed piece. The thickness with which the clay body of the dish has been formed makes some think it must be a late work, but it should be realized that such thickness was not unknown among early pieces.

29. *Enameled Nabeshima 7-sun dish, phoenix design. D. 19.8 cm.*
This is an unusual design for Nabeshima. An outstanding piece.

30. *Enameled Nabeshima 7-sun dish, rhododendron design. D. 20.3 cm.*
The bold composition featuring rhododendrons and azaleas is typical of the Nabeshima style. Another plate with the same design, but with rhododendron leaves in underglaze cobalt is part of the collection of the Kyūsei Atami Art Museum.

31. *Enameled Nabeshima 7-sun dish, vegetables design. D. 20.3 cm.*
A beautiful enameled Nabeshima 7-*sun* dish. Only thirty or so of this dish design were made as gifts, and very few of them have survived to this day. Underglaze cobalt versions with an identical design were also made.

32. *Enameled Nabeshima 7-sun dish, floral pattern. D. 19.9 cm. Imaemon Antique Ceramics Center.*
This reassuringly solid composition with splendid coloring contains a sense of great power.

33. *Enameled Nabeshima 7-sun dish, cherry blossom design. D. 20.4 cm. Tokyo National Museum.*
The way in which this huge cherry tree in full blossom is so dynamically depicted makes this a magnificent piece, which must date from the Genroku or Kyōhō periods.

34. *Enameled Nabeshima 7-sun dish, peonies and ocean wave design. D. 19.8 cm.*
A truly majestic design featuring ocean wave pattern and peonies done in the "ink resist" technique. This is among the most famous of the 7-*sun* dishes.

35. *Enameled Nabeshima 7-sun dish, peony and scroll pattern. D. 20.5 cm. Okayama Art Museum.*
I have selected this piece as a representative example of patterned designs, among which are found more technically outstanding works than among other categories.

36. *Enameled Nabeshima 7-sun dish, camellia design. D. 20.2 cm.*
A powerful composition of great beauty, in which camellias are boldly painted in full flower.

37. *Enameled Nabeshima 7-sun dish, flowers and jars design. D. 19.5 cm. Okayama Art Museum.*
The pale green leaves pulsate with a sense of life. Some think this must be a late work, principally on the grounds that the cobalt is rather thin, but there is little doubt that this is a masterpiece of the golden age.

38. *Enameled Nabeshima 7-sun dish, peaches and treasures design. D. 20.0 cm. Imaemon Antique Ceramics Center.*
So far as I know, this is the only dish of its kind to have survived. The design is unusual, to say the least, and quite elaborate; technically, it is inferior to no other such dish.

39. *Enameled Nabeshima 7-sun dish, braided cord design. D. 20.3 cm. Okayama Art Museum.*
There are very few 7-*sun* dishes to be found with this design. It was a considerable surprise for me to discover, therefore, that a similar work existed abroad when I came across an identical piece in the Leiden Museum of Ethnology.

40. *Enameled Nabeshima octagonal dish, treasures design. 21.0 cm. × 19.6 cm. Imaemon Antique Ceramics Center.*
In design and technique, this is indeed a remarkable work. It is undoubtedly a first-class enameled Nabeshima 7-*sun* dish.

EARLY NABESHIMA LARGE DISHES

41, 42. *Early enameled Nabeshima large dish, snow and chrysanthemums design. D. 25.7 cm. Bauer Collection, Geneva.*
The dish depicts the first snowfall of the year, when chrysanthemums are still in bloom. The pattern on the underside is geometric and covers most of the surface, including the foot rim, a feature that is most unusual and shows that this is an early Nabeshima dish completed before standardization was introduced.

43. *Early enameled Nabeshima large dish, oak and birds design. D. 30.0 cm.*
This dish and the one immediately preceding best represent the splendor of the early Nabeshima period. The design is characterized by bold strokes and thick enamel, while the enameled pattern on the rim is quite unusual. Although it is reminiscent of old Kutani, there is no doubt that this is a rare Nabeshima piece.

EARLY NABESHIMA DISHES

Unlike the later period, the early period of Nabeshima production was not characterized by standardization, but, rather, various shapes and sizes were produced. Many early period pieces have been discolored over the years

through use and are thus often not easily identified as Nabeshima. However, a glance at the foot-ring patterns on any questionable pot will allow it to be clearly identified.

Many early Nabeshima pieces were not bisque fired, but were decorated with underglaze cobalt directly on the green pot. Also, many pieces were mold formed.

44. *Early enameled Nabeshima lobed dish. 16.3 × 13.0 cm. Imaemon Antique Ceramics Center.*
Nabeshima pieces of this kind were once thought to have been reenameled, but the discovery of this piece made it clear that both base and top design are authentic. Hence, this piece has played a vital role in establishing a historical category. Moreover, the dish shows that early Nabeshima pieces may come with rather heavy enamel colors reminiscent of Kutani ware.

45. *Early enameled Nabeshima dish, camellia chain design. 15.2 × 13.2 cm. Imaemon Antique Ceramics Center.*
The technical perfection of the underglaze cobalt pattern casts doubt on the early period origin of this dish, but the thick tone of the enamel identifies it as an early work. The technique of leaving the petals of the camellias unpainted is extremely attractive and makes this one of the more interesting and superb examples of Nabeshima ware.

46. *Early enameled Nabeshima 5-sun dish, willow and swallows design. D. 15.6 cm. Imaemon Antique Ceramics Center.*
For an early Nabeshima piece, the design is exceptionally free and pictorial. The pale green willow leaves have no cobalt underpainting, unlike the enameled Nabeshima of the golden age. The underside of the dish displays the comb-tooth pattern associated with the golden age, but there is little doubt that this piece comes from the early period, although, as such, it is quite exceptional in more than one sense.

47. *Early enameled Nabeshima 5-sun dish, textile print pattern. D. 15.0 cm.*
Early Nabeshima pieces of this kind were once suspected of having been reenameled during the Meiji period or later, since their colors differ from those found on works from the golden age, but the discovery of the lobed dish shown in Plate 44 confirmed the early Nabeshima origin of this piece.

48, 49. *Early enameled Nabeshima dish, rust glaze ground. 16.8 × 12.8 cm. Tokyo National Museum.*
This piece was once regarded as possibly having been painted over a Kutani base, but there is no doubt that it is in fact enameled Nabeshima because the characteristic "heart" pattern appears on the foot rim. Identifying early enameled Nabeshima pieces is a difficult task indeed.

50. *Early enameled Nabeshima dish, azure glaze, chrysanthemum design. 15.0 × 12.5 cm.*
The chrysanthemum design on this mold-formed dish is in slight relief. The design is not typical of Nabeshima ware, and the azure glaze is rather harsh, but the comb-tooth pattern on the foot rim identifies the piece as genuine Nabeshima.

51. *Early Nabeshima dish, celadon and cobalt, radish design. D. 15.7 cm.*
This rare celadon and cobalt piece was mold formed. The design has been drawn in what is known as the "ink resist" (*sumi-hajiki*) method. This involves first painting the basic design in ink, the areas remaining uninked being filled with underglaze cobalt pattern. The piece is then bisque fired twice in order to burn off the ink and reveal the white porcelain ground. This dish is thought to have been made after the clan kiln moved to Ōkawachi-yama.

52. *Early Nabeshima 5-sun dish, cobalt and celadon, floral pattern. D. 15.2 cm.*
A rare work, the tone of the celadon is pleasant, and the cobalt pattern is well executed.

53. *Early Nabeshima 5-sun dish, cobalt and rust glaze, eggplant motif and floral pattern. D. 15.3 cm.*
This is a rare work whose value lies in the way in which the inside of the eggplant form has been filled with a cobalt pattern.

54. *Early Nabeshima dish, cobalt and celadon, crane design. D. 15.4 cm. Imaemon Antique Ceramics Center.*
Early Nabeshima pieces are characterized by being rather thick, and so this dish is thought to have been made after the kiln's transfer to Ōkawachi-yama. The skillful depiction of the crane and the pleasant tone of the celadon make this an impressive piece.

LARGE COBALT-DECORATED AND THREE-LEGGED DISHES

55, 56. *Three-legged enameled dish, design of playing the koto under a pine. D. 28.5 cm.*
Its design makes this piece the rarest of all 1-*shaku* enameled Nabeshima dishes. This design led some scholars to believe that the piece was of rather late origin, but today it is accepted as an authentic, old masterpiece because of its color combinations, the skill with which the dish has been painted, and the unquestionable uniqueness of the design. So far as I am concerned, searching for rare masterpieces lying concealed in the limbo of art history is part of my joie de vivre.

57, 58. *Three-legged dish, cobalt, heron design. D. 28.0 cm.*
This dish has an aura of some distinction because of the artistic and perfect execution of the cobalt design. The thin azure is of an indescribable beauty and quite effectively imparts a feeling of cleanliness, a quality inherent in cobalt underglaze decorated porcelain, of which this piece is a champion specimen. It is displayed (on loan) at the Yūtoku Museum in Kashima City, Saga Prefecture.

The category of three-legged dishes is best represented by the two pieces shown here, for they both reveal the technical heights that Nabeshima wares attained.

59, 60. *Large dish, celadon and cobalt, waterwheel and wave design. D. 30.3 cm. Imaemon Antique Ceramics Center.*
This piece was also exhibited at the Seattle Japanese ceramics exhibition of 1972 and features an unusual design for a large celadon and cobalt dish. Unfortunately, the piece is cracked,

and it is perhaps for this reason that it has been kept stored away for some time. I had long forgotten about it, but, renewing my acquaintance with the dish, I was struck by the perfection of its design.

61, 62. *Large dish, cobalt, landscape design. D. 30.5 cm.*
Although large cobalt-decorated dishes were made in great numbers during the later years of Nabeshima production, very few of the superb works dating from the Genroku and Kyōhō periods have survived to this day. The design on this dish, featuring a Chinese-style land-and-waterscape is very rare. This piece was brought back from Germany in recent years. Many old Imari, Nabeshima, and Kakiemon pieces of superior quality were shipped out of Japan during the Meiji and Taishō periods and became part of private collections abroad. It is thus a rewarding pastime to search out these pots, to purchase them, and to bring them back to Japan from various parts of the world.

LARGE ENAMELED NABESHIMA DISHES
During the years that Nabeshima flourished, the ware consisted of certain fixed shapes and sizes, which included *shaku hachi*, dishes with a diameter of one *shaku* (10 *sun* or 30 cm.); 7-*sun* (21 cm.) dishes; and 5-*sun* (15 cm.) dishes. Of these, the 1-*shaku* dishes are by far the most remarkable both for their size and for the vividness of their designs. To date, some twenty-five have been identified, but of these only ten or so are found in Japan. Some of the finest pieces are shown here.

63, 64. *Large enameled Nabeshima dish, peony, rock, and flowerpot design. D. 30.9 cm. Kurita Art Museum.*
By far the most important of the large dishes known to exist in Japan, this piece was exhibited at the major Japanese ceramics exhibition held in Seattle in 1972.

65, 66. *Large enameled Nabeshima dish, treasures design. D. 30.3 cm. Okayama Art Museum.*
A favorite Japanese theme with auspicious meaning features stylized treasure motifs in combination with a wave pattern (see Plate 73). In this piece, the enamel colors are beautifully clear, and the piece itself is undoubtedly one of the finest among large Nabeshima dishes.

67, 68. *Large enameled Nabeshima dishes, peaches design and mandarin orange design. D. 31.7, 30.0 cm. Kyūsei Atami Art Museum.*
One cannot discuss large enameled Nabeshima dishes without mentioning these two pieces. The vivid colors, the execution of design, and the high level of craftsmanship indicate the golden age of Nabeshima production.

Although not clear from the photograph, the peaches are in fact exacted with extraordinary precision, being painted with cobalt and enamel dots. The background is in *usu-dami*, a painstaking technique that involves painting a coat of thin cobalt to in fill the space.

Nabeshima is also known for the emphasis it places on crooked tree trunks executed with bold strokes in dynamic compositions. The mandarin orange tree design in Plate 68 is a splendid example of this Nabeshima tradition.

69. *Enameled Nabeshima container in the shape of a tea ceremony hot water kettle, design of tea picking. H. 17.8 cm. Tanakamaru Collection.*
Some may wonder if this is really a Nabeshima pot, but a look at its bottom reveals as many as twenty-four characteristic niches. These, together with the uniquely Nabeshima elaborate craftsmanship, serve to identify this piece as an authentic Nabeshima work. Of course, those used to footed Nabeshima dishes will find the design and use of gold on this pot a little unusual, but let them be assured that this is without any doubt a Nabeshima masterpiece. It was once part of the collection of a Mr. Robinson.

70. *Enameled Nabeshima incense stand, vine design. H. 10.8 cm.*
Apart from the pot in the preceding plate and also a bottle-shaped vase, this is the only other full-bodied form of enameled Nabeshima. This incense burner is a modest-sized piece, but one can tell at once that workmanship of no ordinary caliber went into it. It is truly a beautiful specimen of enameled Nabeshima.

THE BAUER COLLECTION
The Bauer Collection of Geneva, Switzerland, contains a large number of old Chinese, Korean, and Japanese ceramics and other works of art that Mr. Bauer, a Singapore-based Swiss trader, began to amass in Japan from about 1931. This collection has recently been opened to the public in a museum. In it may be found as many as seven large enameled Nabeshima dishes, and it is believed to be the only collection in the world that treasures so many precious items from the Nabeshima kiln. Two of them are shown here.

71, 72. *Large enameled Nabeshima dish, rock and kerria flower design. D. 30.8 cm. Bauer Collection, Geneva.*
Although large dishes with rock-and-orchid designs have survived in Japan, this particular piece with kerria flowers is an extremely rare one. A decorative garden stone is placed at the base of the composition, and above it sprigs of kerria are arranged. So far as I know this design is unique, and hence a special request was made to the museum board to photograph and reproduce the bowl in this volume.

Mr. Bauer appears to have had a particular predilection for enameled Nabeshima, and the collection he has left contains more or less complete series of the more representative 7-*sun* (21 cm.) and 5-*sun* (15 cm.) dishes. It was, however, astonishing to find seven large dishes in the collection as well. Among these is one with a wagtail design such as is frequently seen in 5-*sun* dishes (see Plate 20), while the other large dishes display shapes and rare designs that are not known in Japan.

73, 74. *Large enameled Nabeshima dish, ocean wave and treasures design. D. 30.6 cm. Bauer Collection, Geneva.*
Masatoshi Ōkōchi suggested that this piece once belonged to Mr. Gatsby, but no one knew what happened to it after it left the hands of this owner. It was later discovered that the piece had been in Switzerland since 1932 as part of the Bauer Collection. We are grateful to the director of the collection museum for giving permission to photograph this dish and reproduce it here.

75. *Large enameled Nabeshima dish, cotton rose and chrysan-*
themum design. Important Cultural Property. D. 32.0 cm.
Not more than twenty-five large enameled Nabeshima
dishes survive intact. All of these pieces are priceless, but if
any one of them is to be singled out as the essential example
of such dishes, the one in this photograph would be the most
appropriate choice. It has been an Important Cultural Prop-
erty of Japan for some considerable time. It possesses an
almost perfect beauty, which derives from the impressive
brushwork and from the dynamic composition of cotton
roses and chrysanthemums, which spreads over the surface
of the dish yet includes minute floral details. This bowl
claims a special place in the world of porcelain art.

It was once owned by a famous English collector named
Robinson, who lived in Kobe during the Taishō period
(1912–25).

76. *Enameled Nabeshima jar, pine, bamboo, and plum design.*
Important Cultural Property. H. 30.6 cm.
This jar is undoubtedly the finest specimen of enameled
Nabeshima. Beneath the classic triad of pine, bamboo,
and plum blossoms are depicted a tortoise and crane, while
on the other side a mandarin orange tree (*tachibana*) is
dynamically drawn. This is a marvelous piece both for the
coloring of its enamels and for the perfection of its form,
and one never grows tired of looking at it. It was first owned
by an Englishman called Gatsby who lived in Tokyo during
the Taishō period (1912–25). He is said to have discovered
it at some out of the way junk shop in Yokohama and put
it on display at the first exhibition organized by the Saiko-
kai. The exact history of the pot thereafter is not known,
but I can recall with a certain sense of nostalgia that at the
end of the war it had passed into the hands of a passionate
Italian collector of old ceramics.

Old Nabeshima Kiln Sites

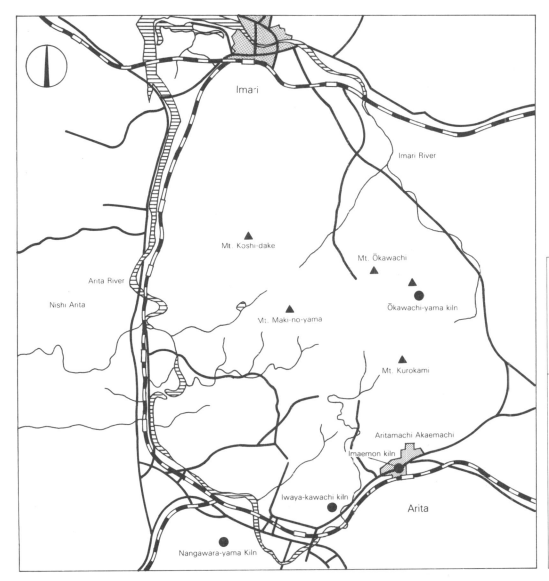

Imari

Imari River

Mt. Koshi-dake

Mt. Ōkawachi

Ōkawachi-yama kiln

Arita River

Nishi Arita

Mt. Maki-no-yama

Mt. Kurokami

Aritamachi Akaemachi

Imaemon kiln

Iwaya-kawachi kiln

Arita

Nangawara-yama Kiln